IF you're reading this, you're our kind of motherfucker. Or you just might be a fan of Dare You Stamp Co. already. And why wouldn't you be? We're awesome. Our line of completely irreverent products is perfect for sticking it to the man and flipping off your haters with style.

Whether you signed your vacation request with our *F This Shit Stamp Kit*, told Santa where he can shove his coal with our *Tis the Season to Be Naughty Postcards*, or became the antihero of your dreams with our *POW! Stamp Kit*, you know we're done being polite. So why not tell the world to fuck off? Break out that pack of crayons you abandoned in middle school and color the fuck out of any number of these swear-filled pages. Frame them, hang them, or leave them all over your boss's desk with your resignation letter stapled to the back. What you do with these are up to you, dumbass. If you feel like showing off, you can tag @cidermillpress on social media and share your fucking awesome creations with the hashtag #fuckoffimcoloring.

Now go forth and be the complete asshole you were meant to be, we dare you.

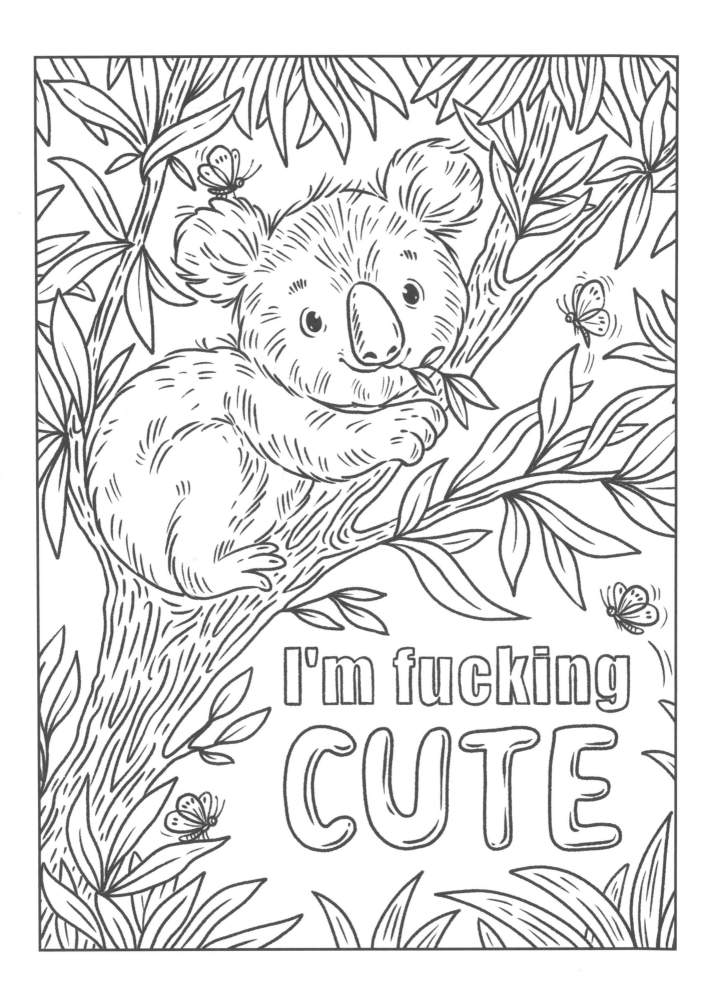

TABLE *of* CONTENTS

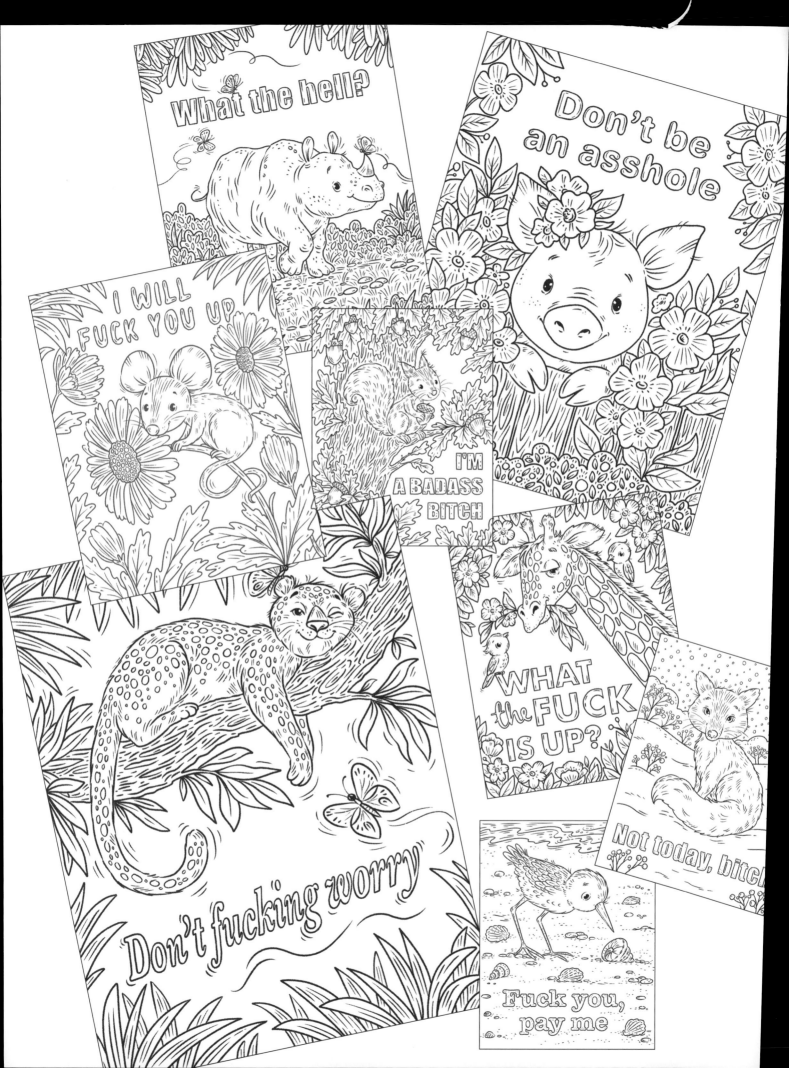

INTRODUCTION

The world can be an ugly place. Depressing news, shitty job, annoying people. Enough already! Why not add some cute color to the day with these pages of foul-mouthed adorable animals, saying everything that you've been thinking? Take some time for yourself. Ignore the haters and the idiots. Tune out the world, let off some steam, and feel the stress disappear as you color the hell out of this coloring book!

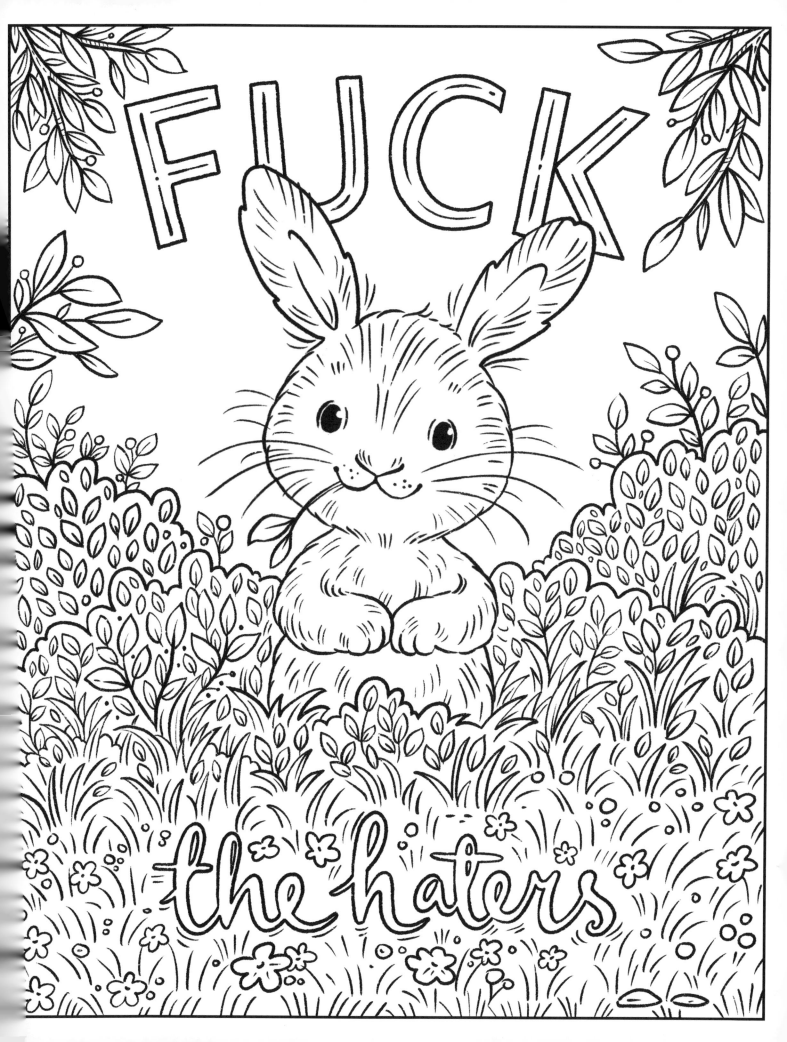

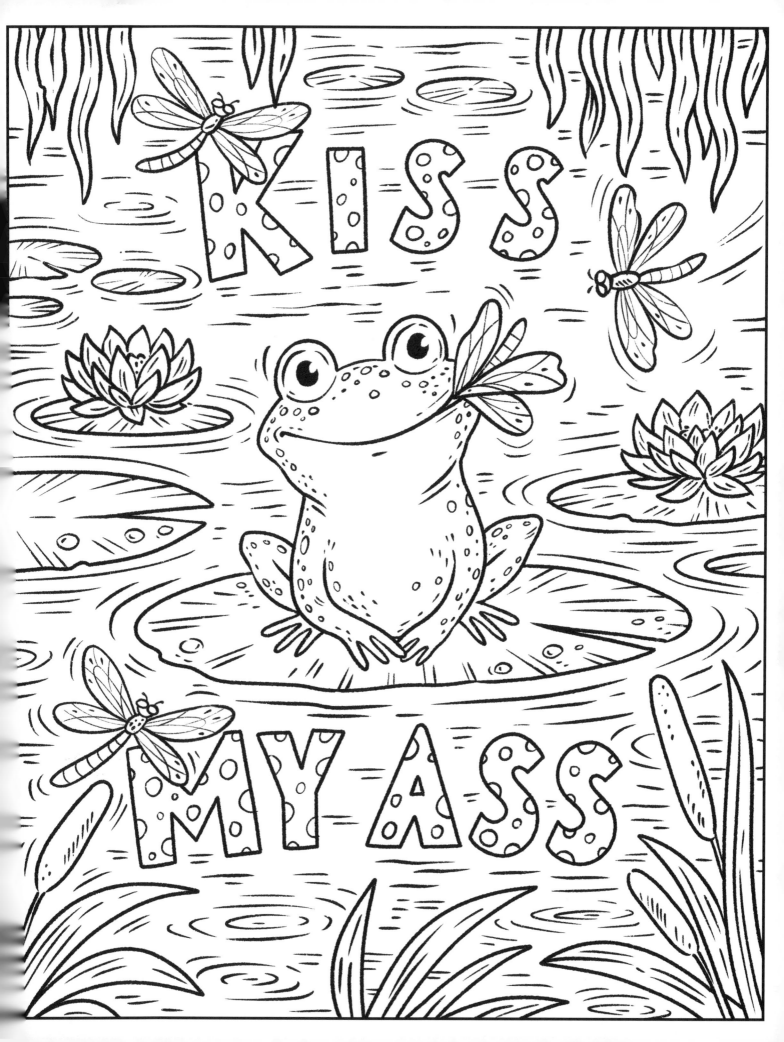

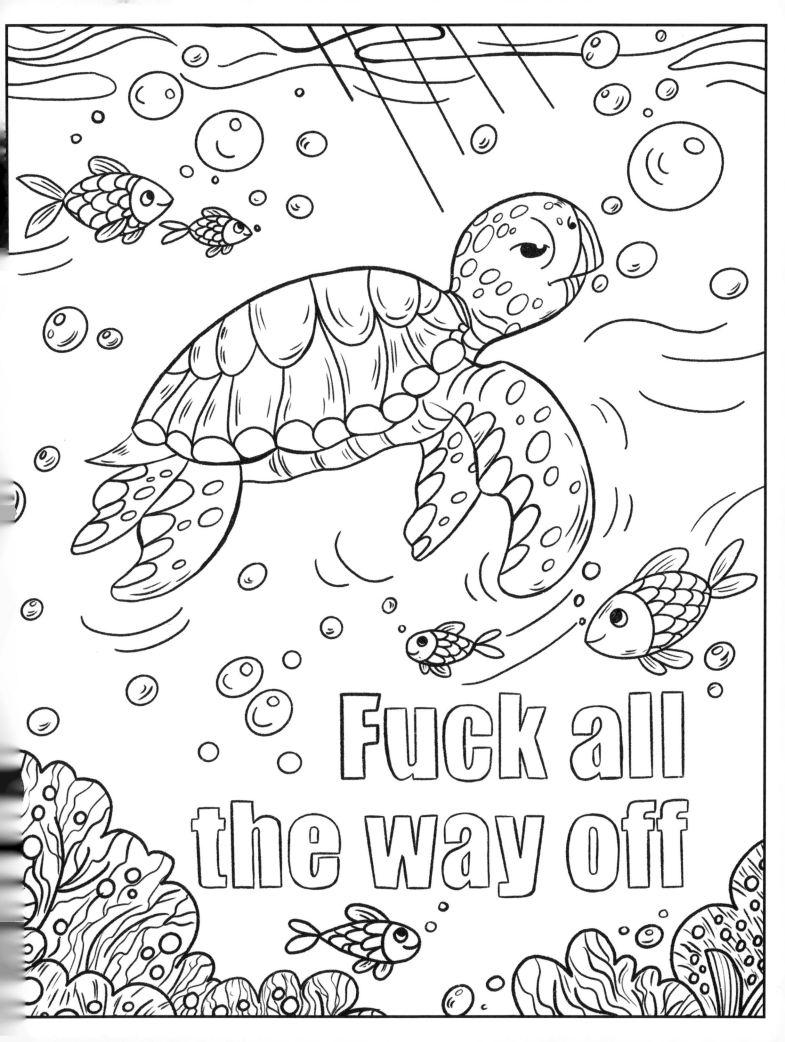

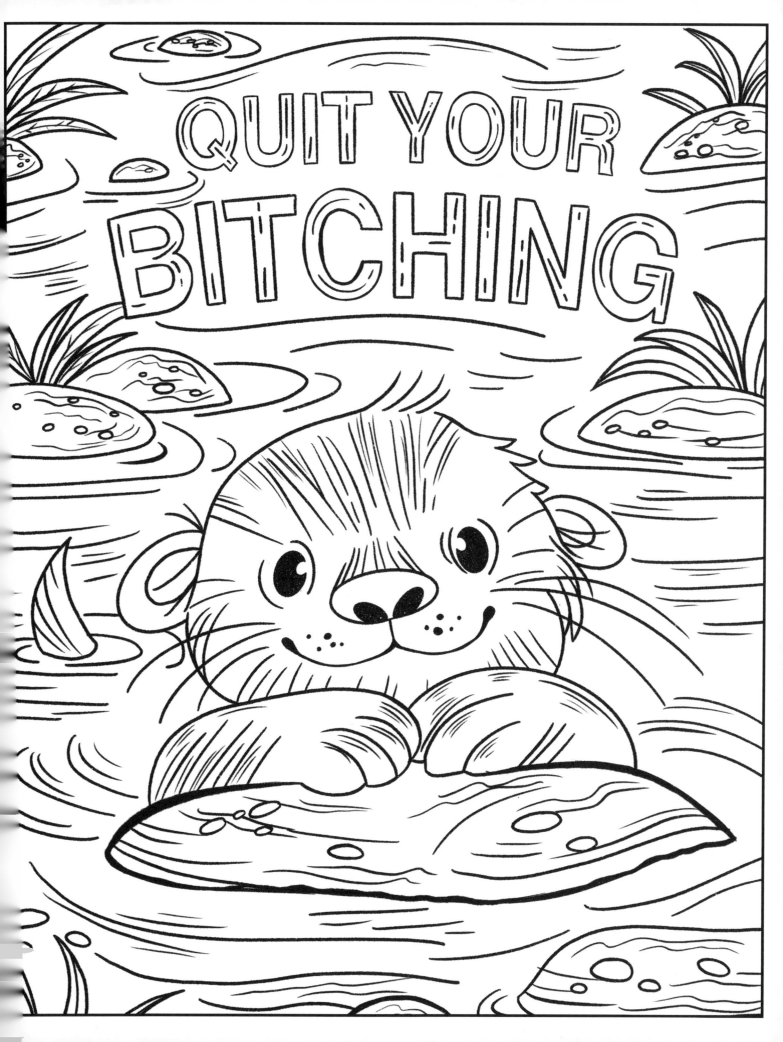

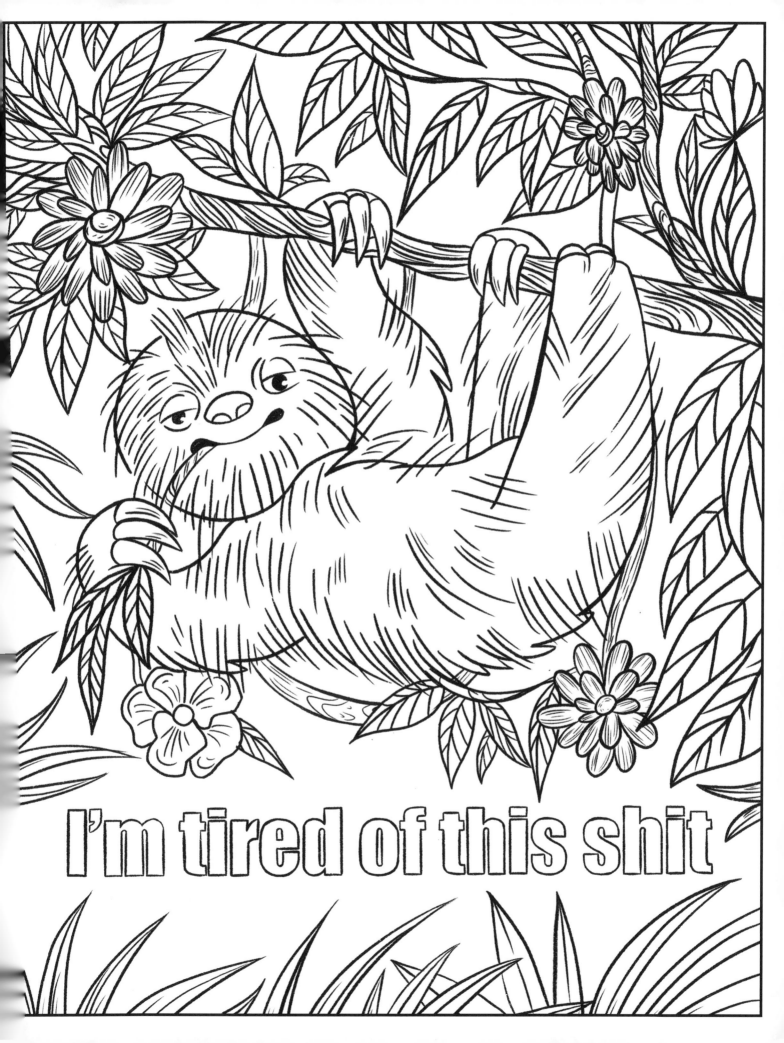

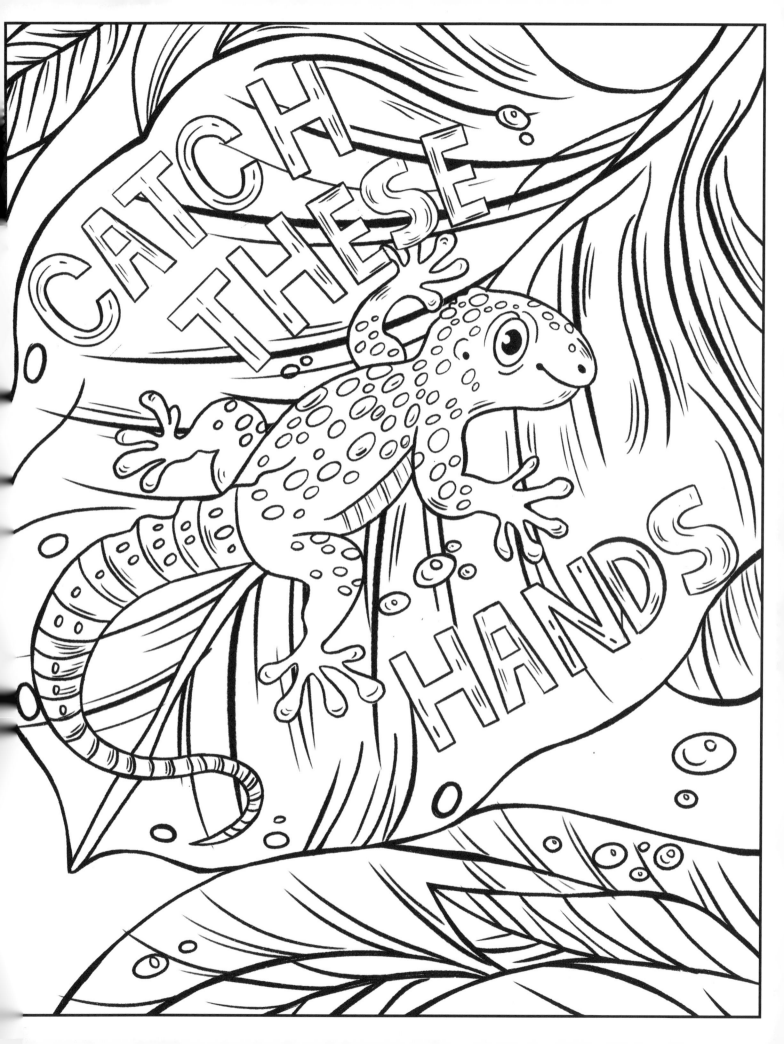

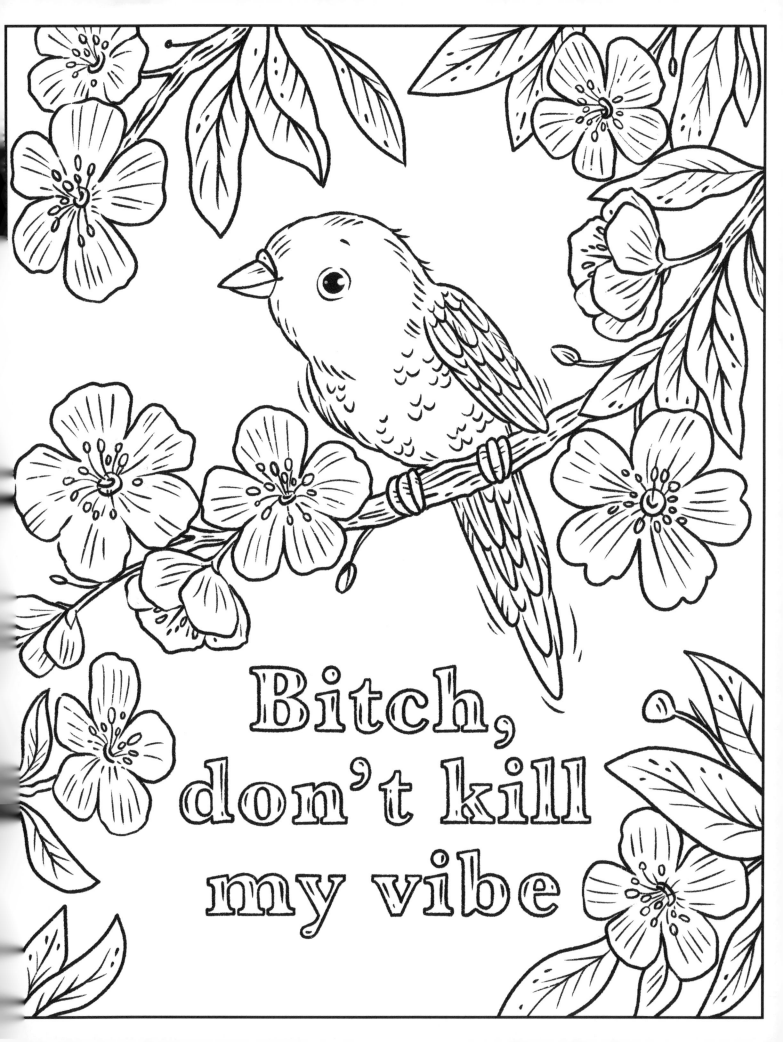

Bitch, don't kill my vibe

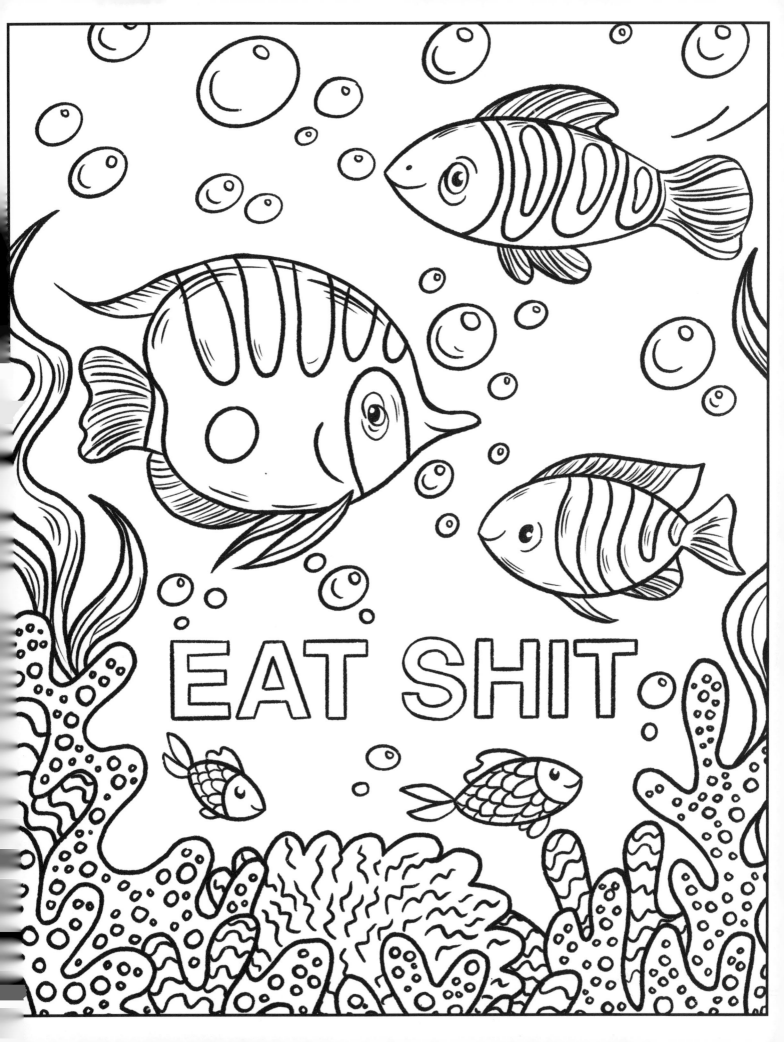

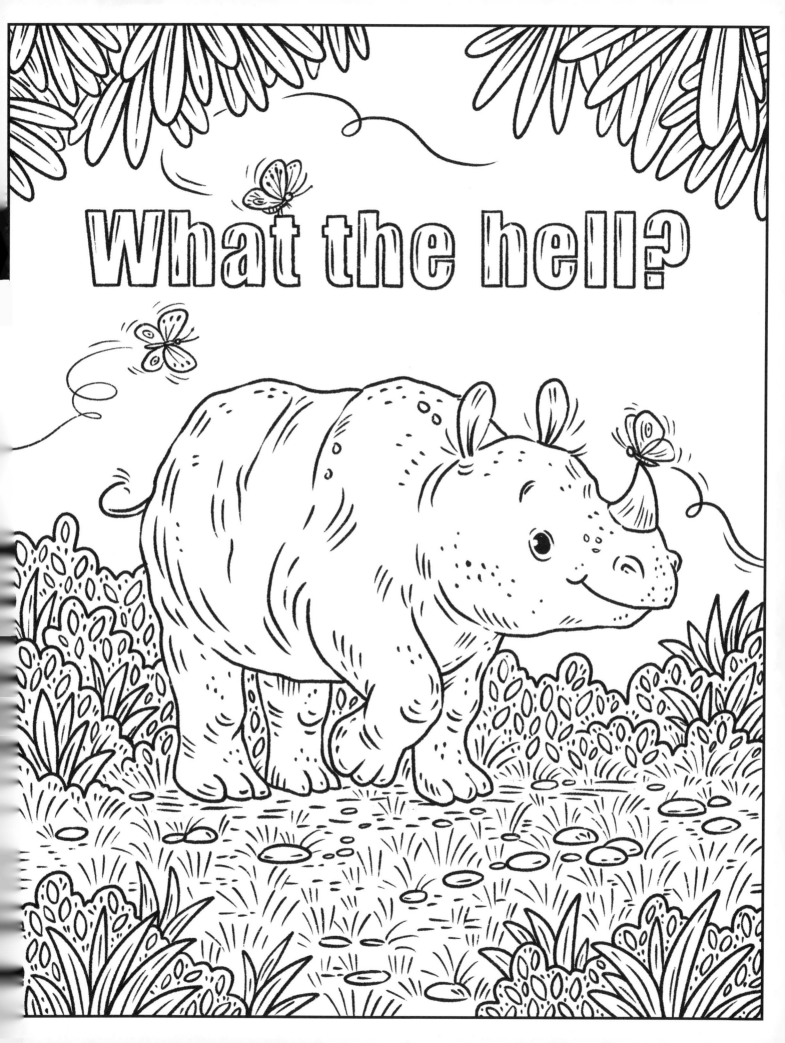

FUCK THE TROLLS

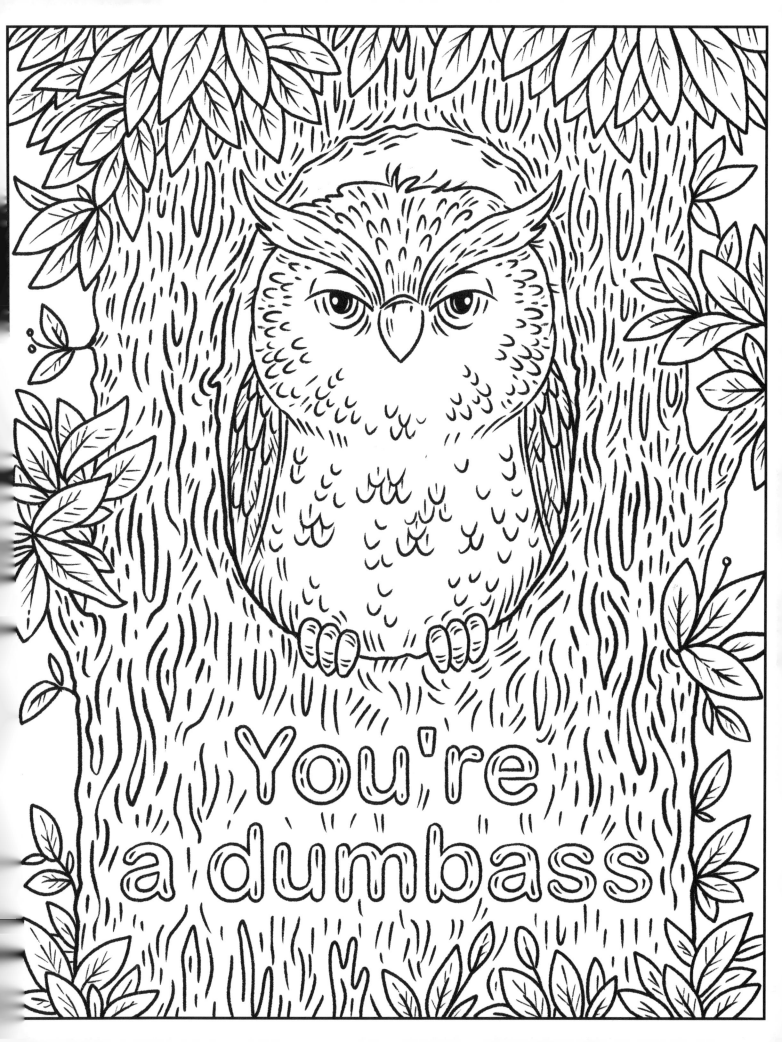

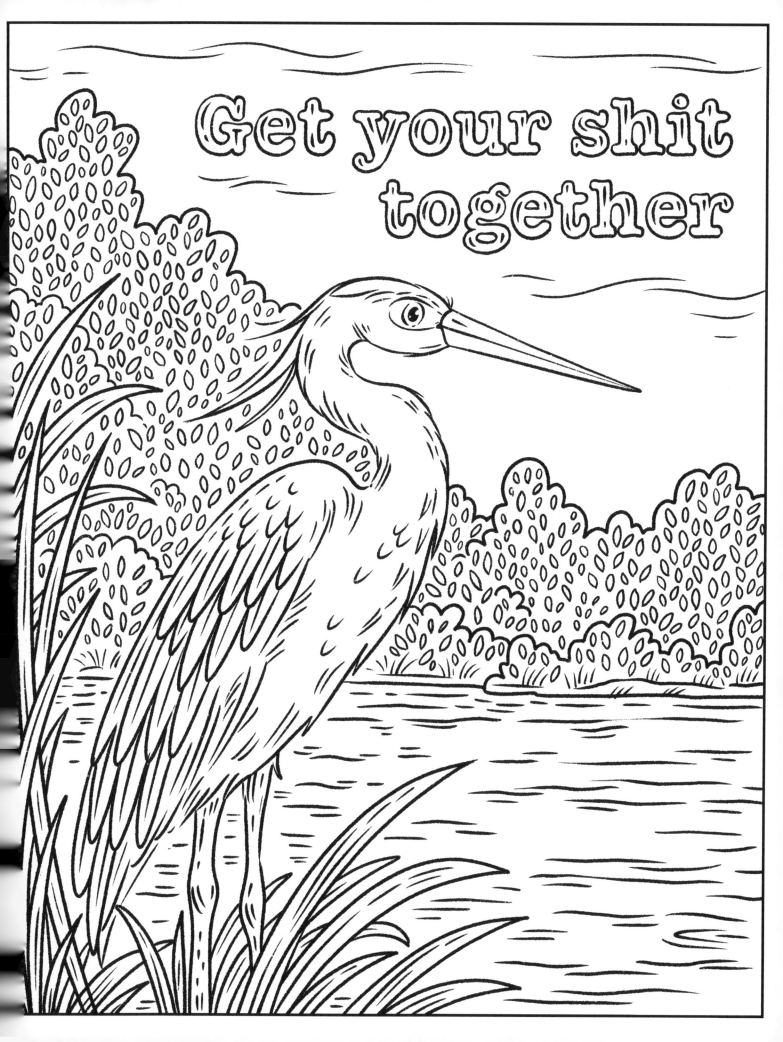

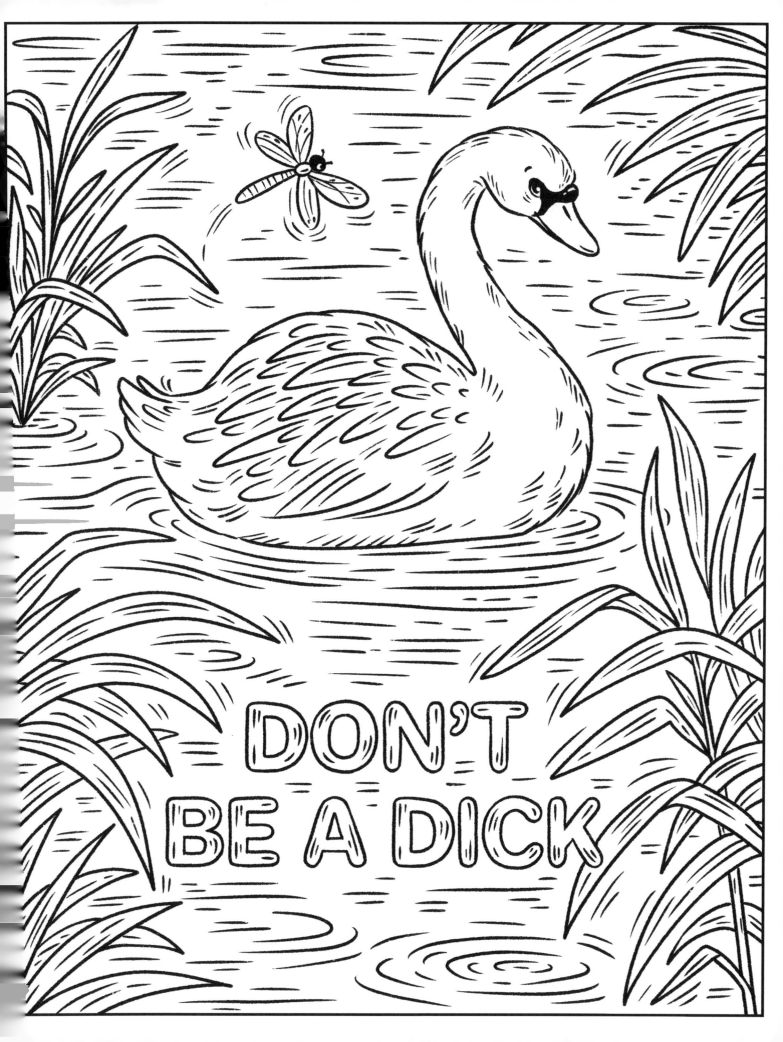

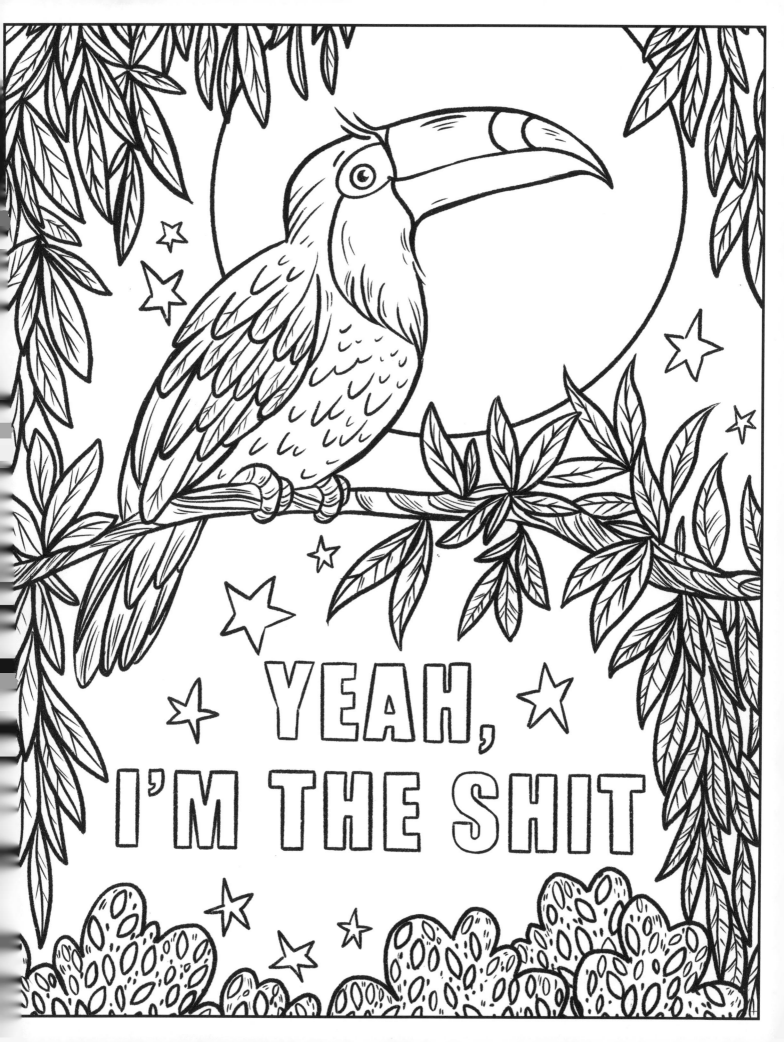

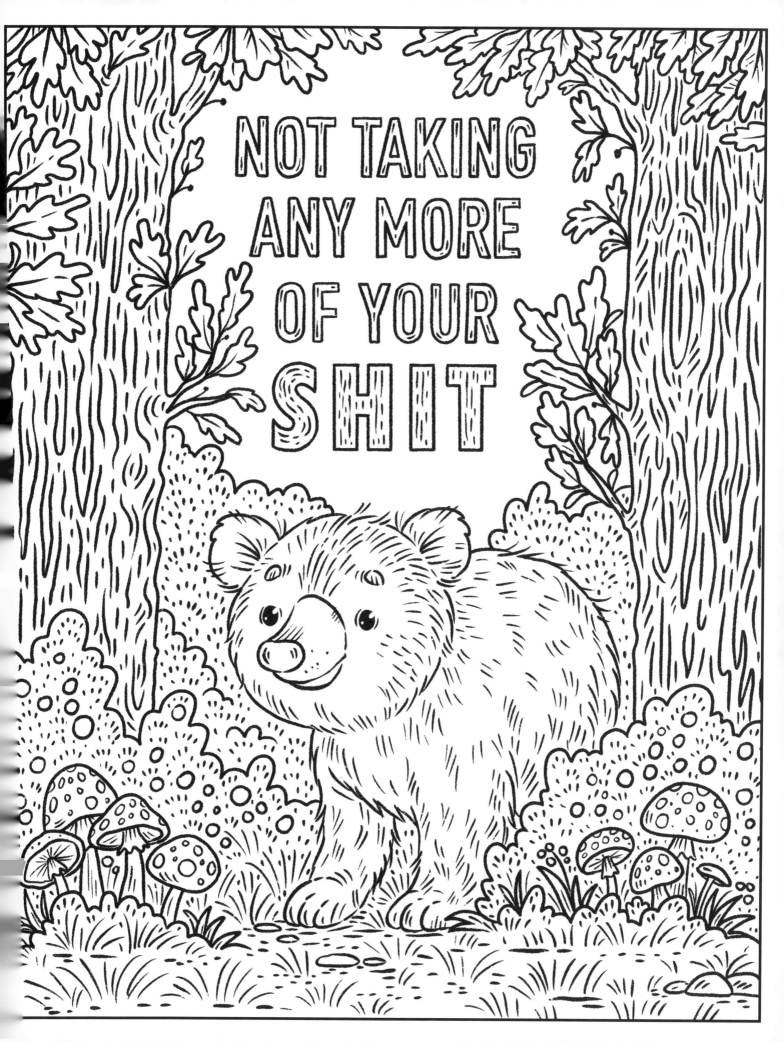

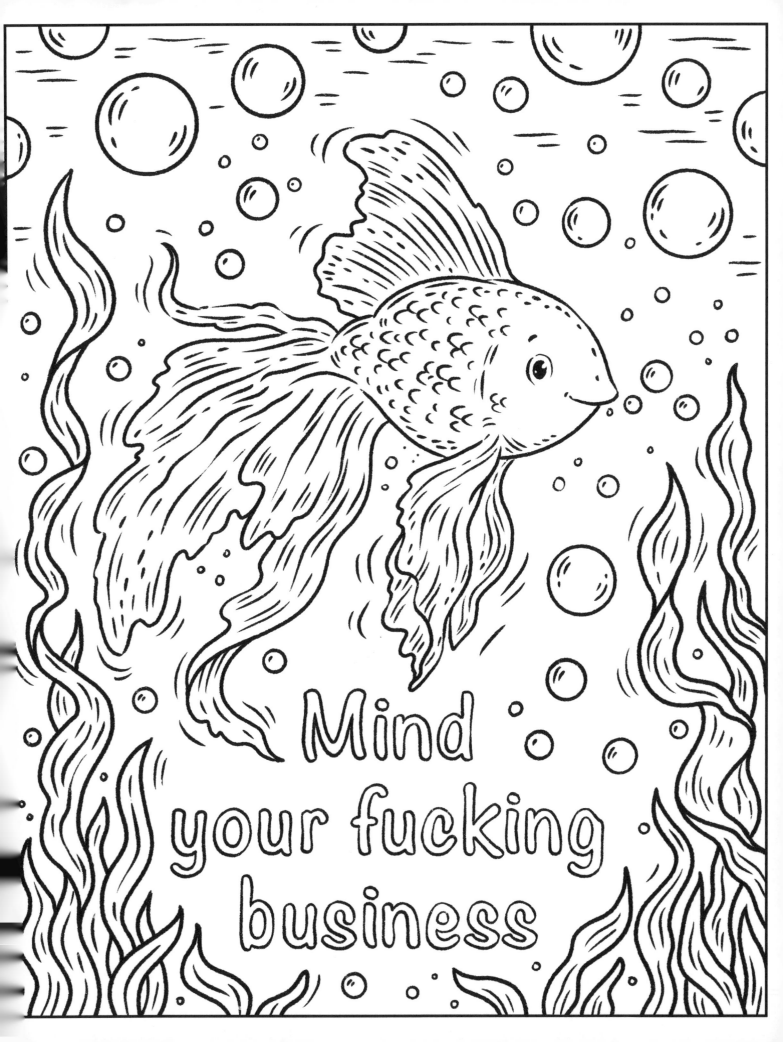

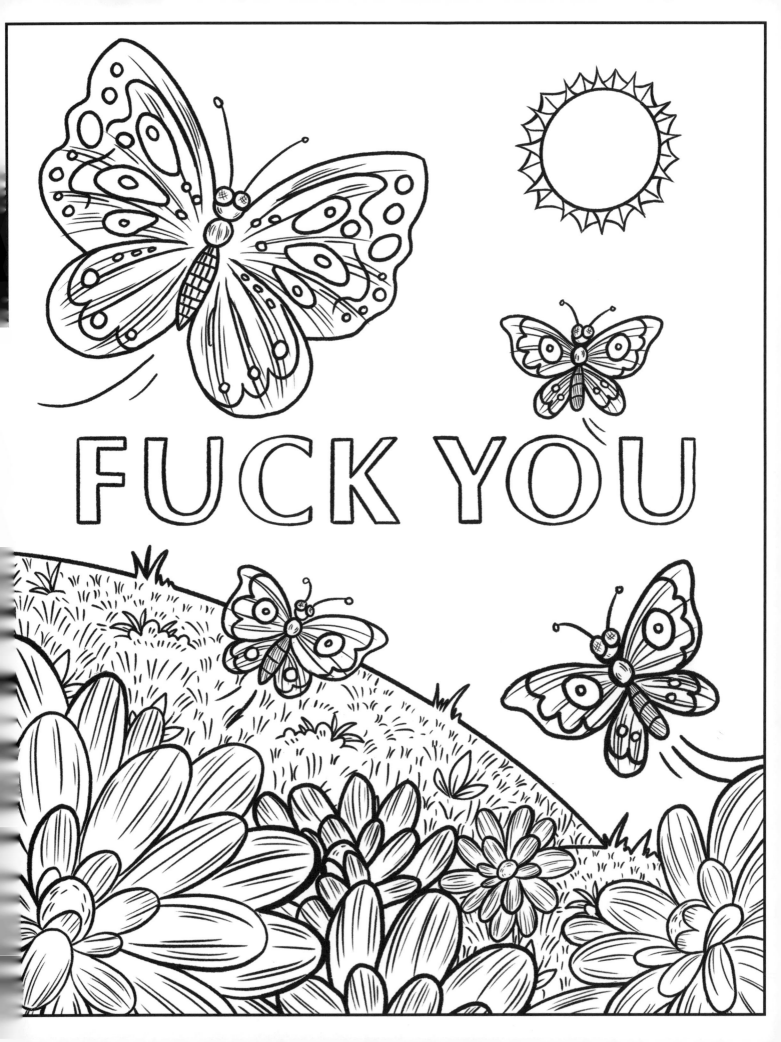

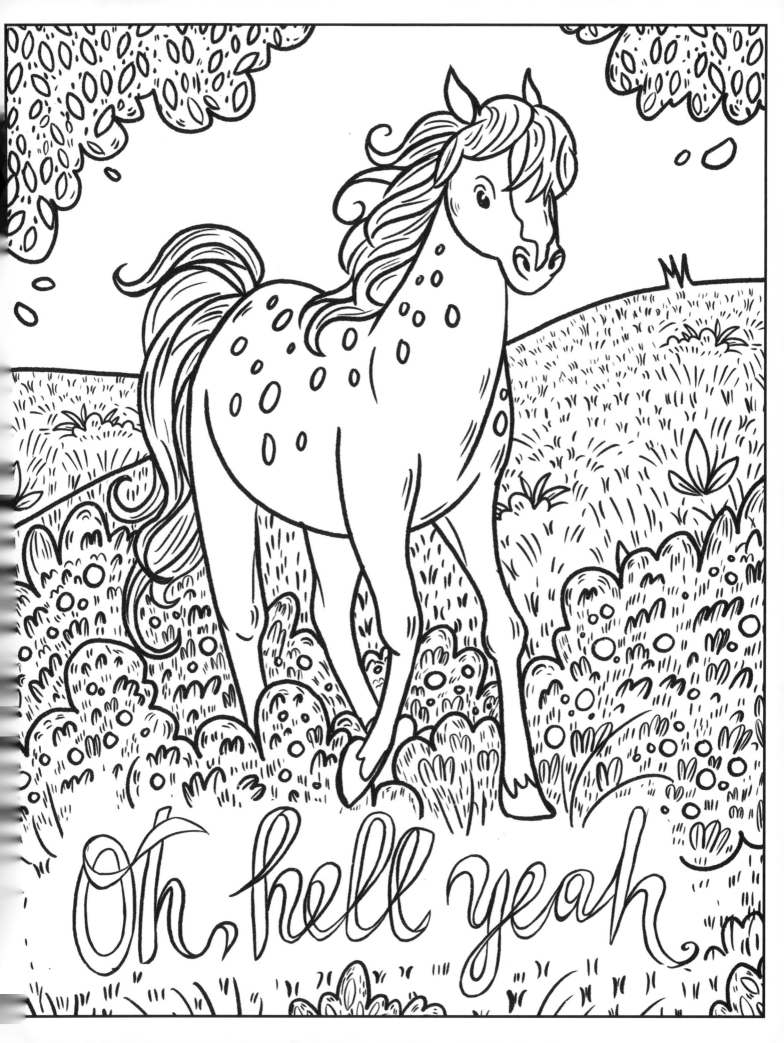

SPEAK TRUTH

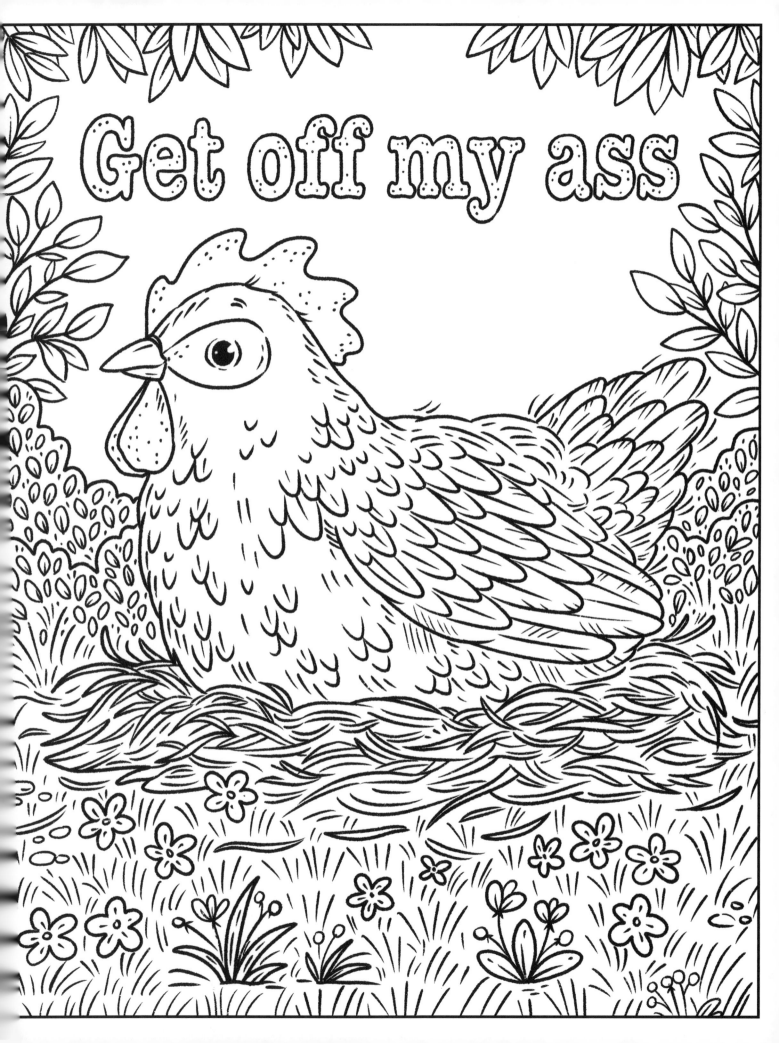

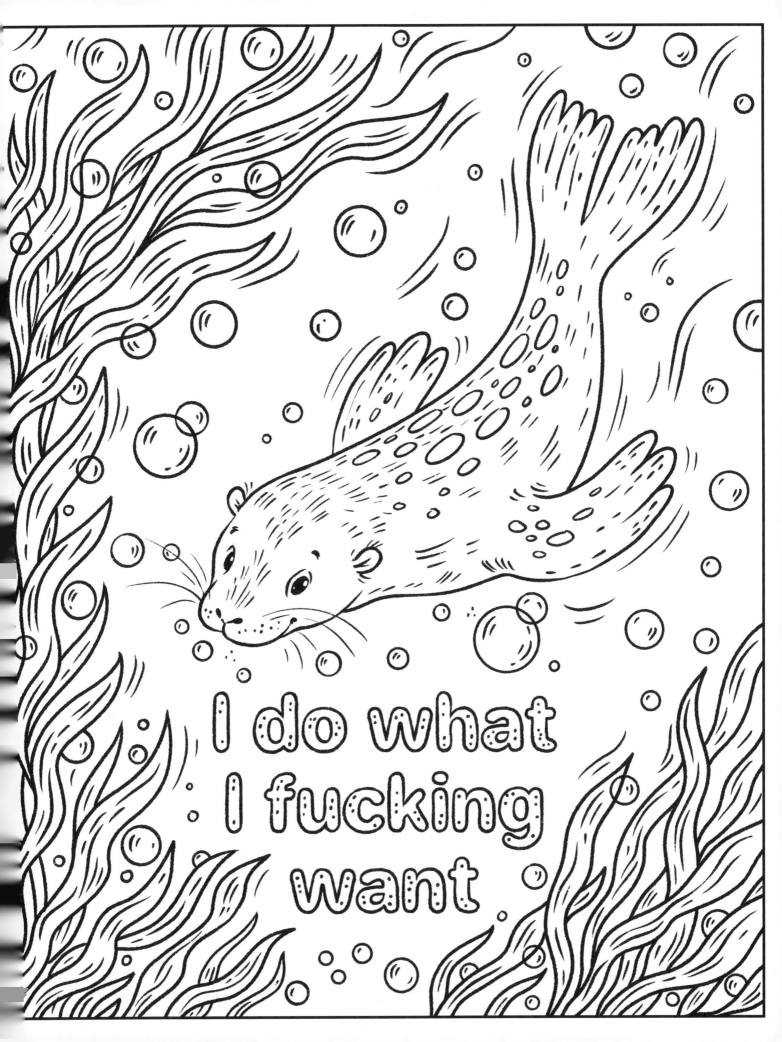

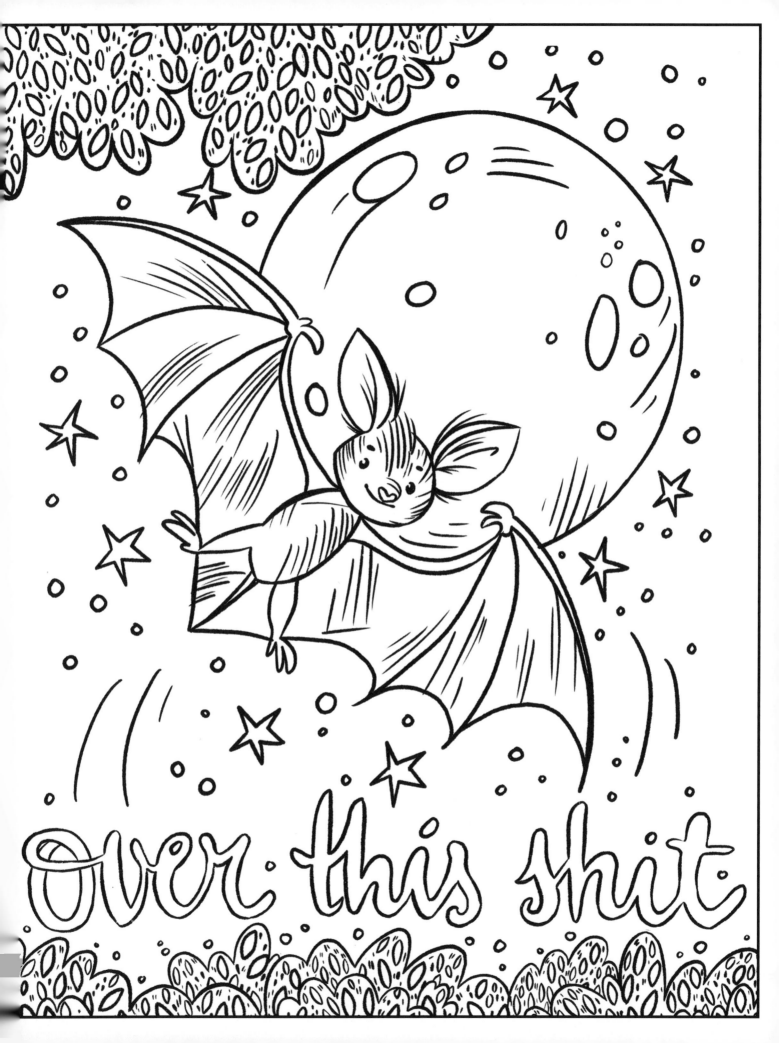

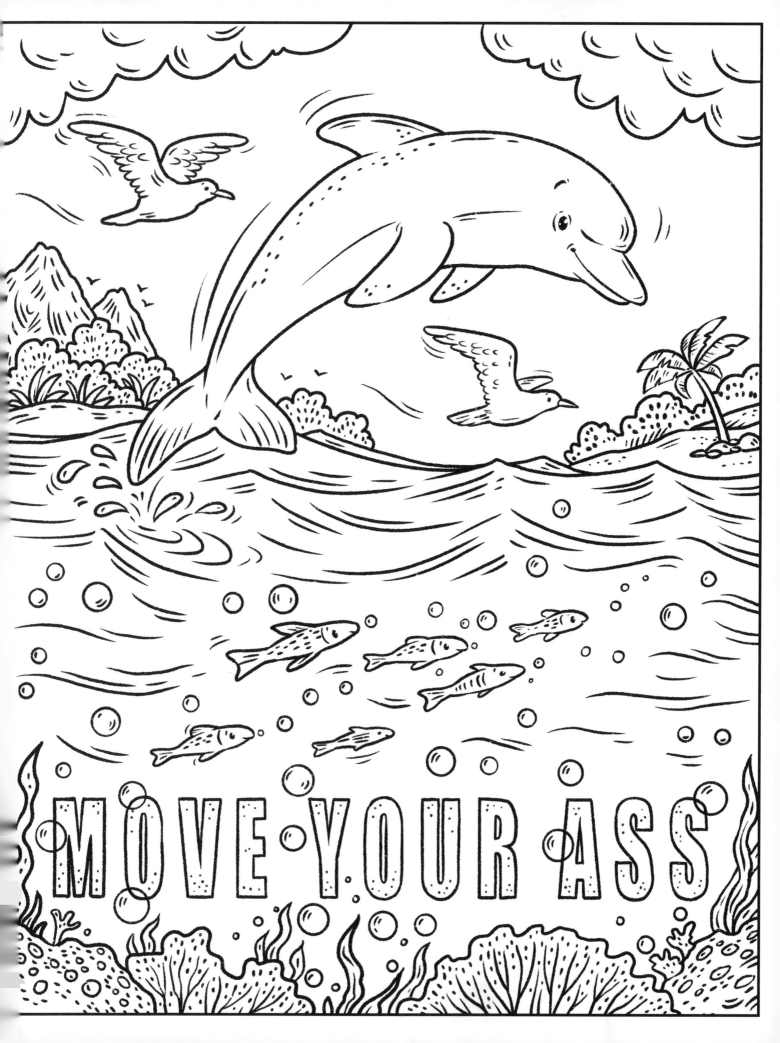

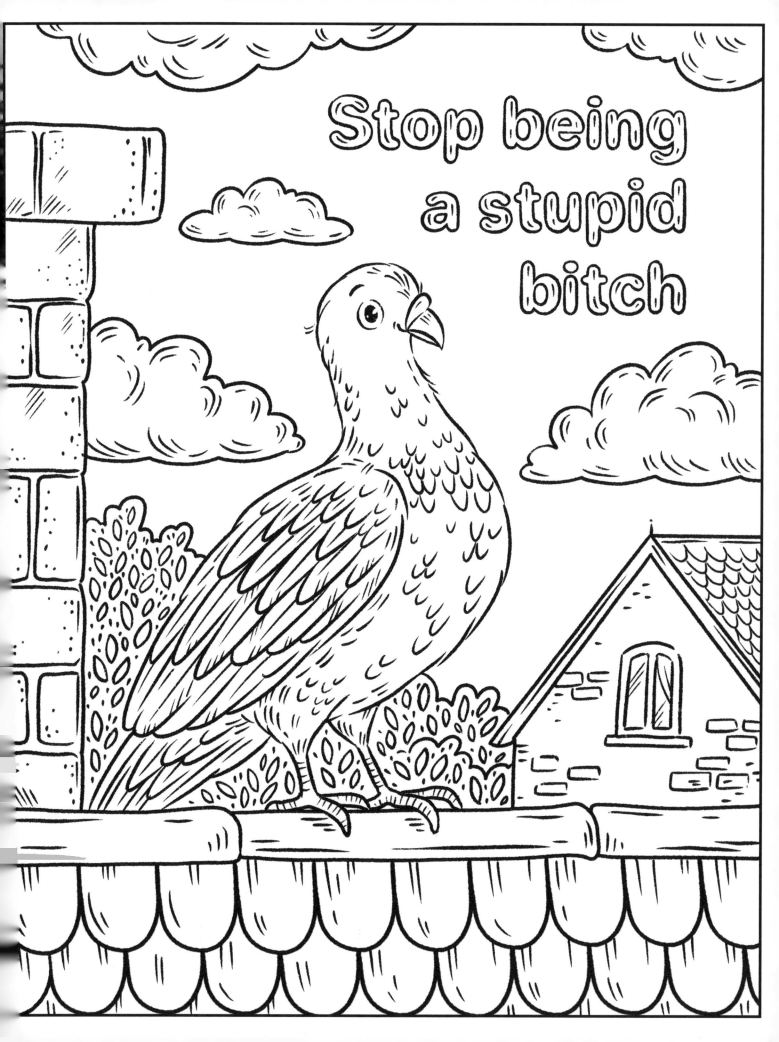

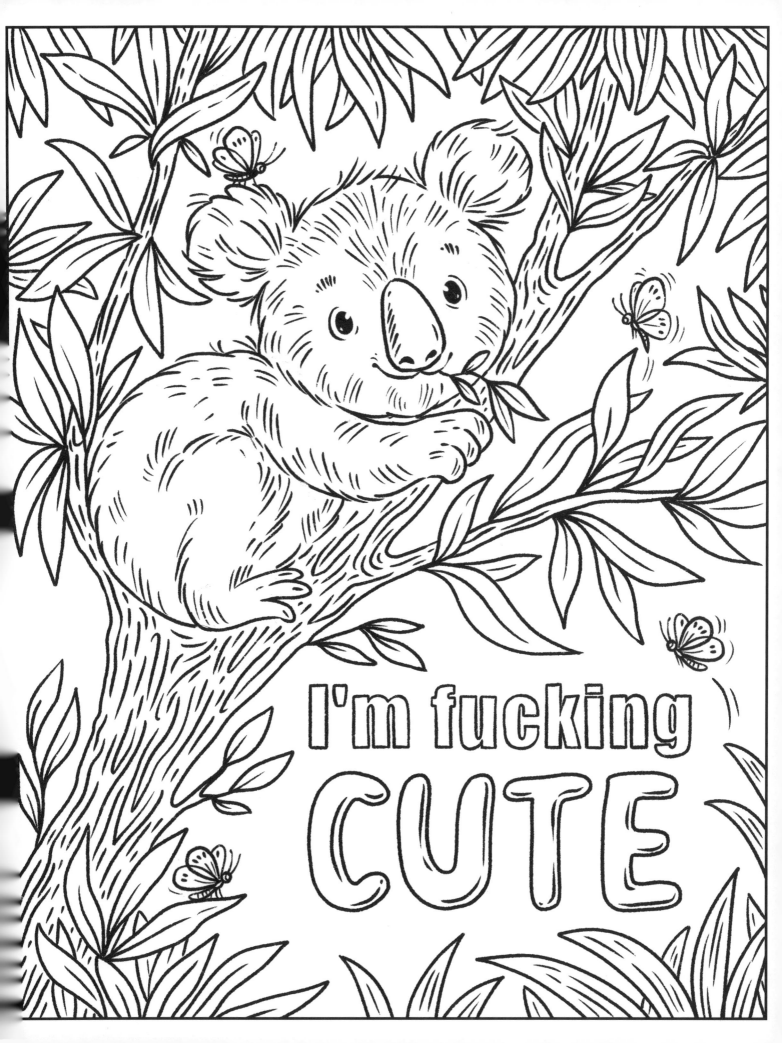

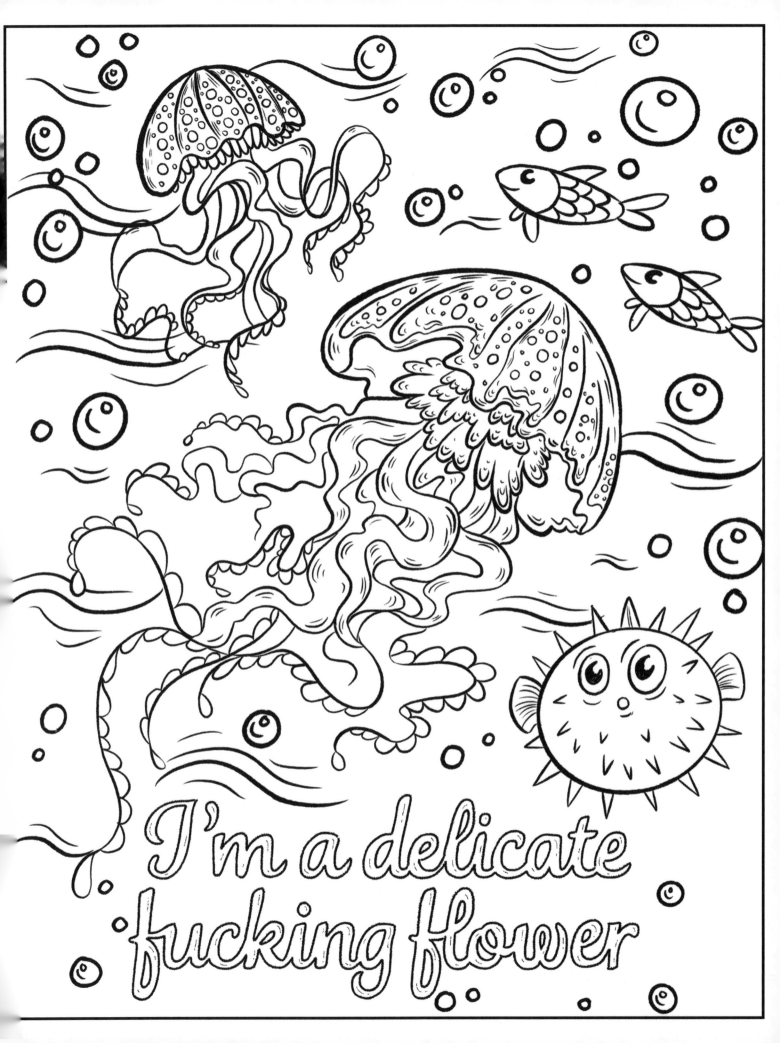

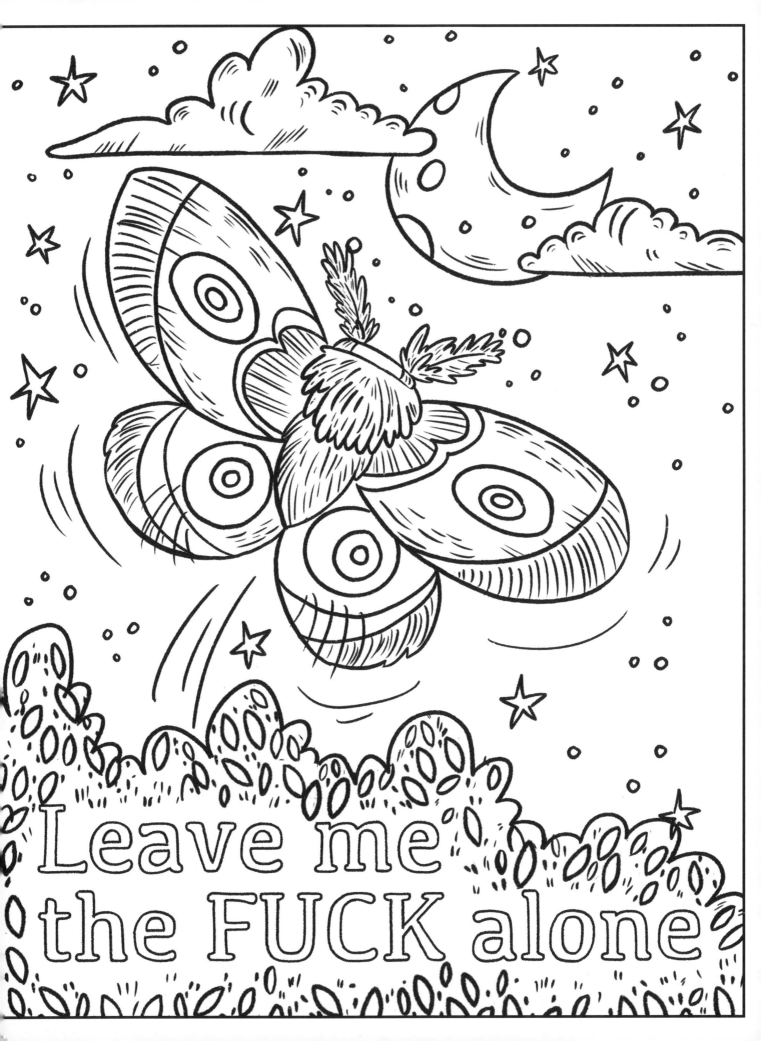

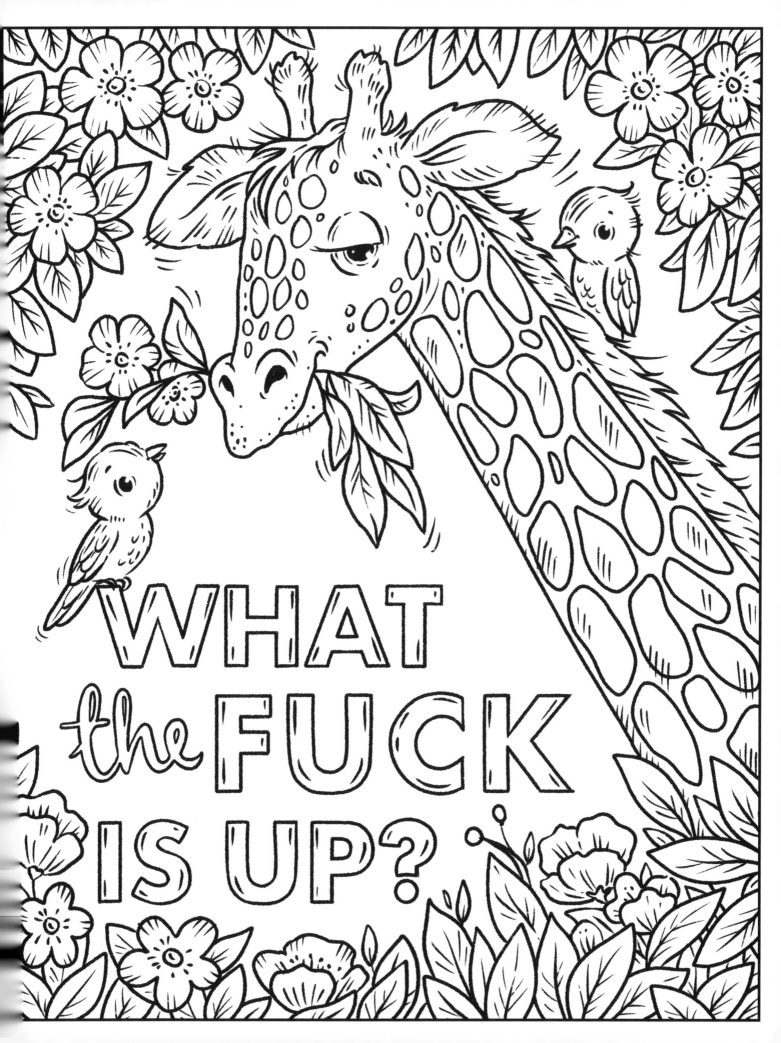

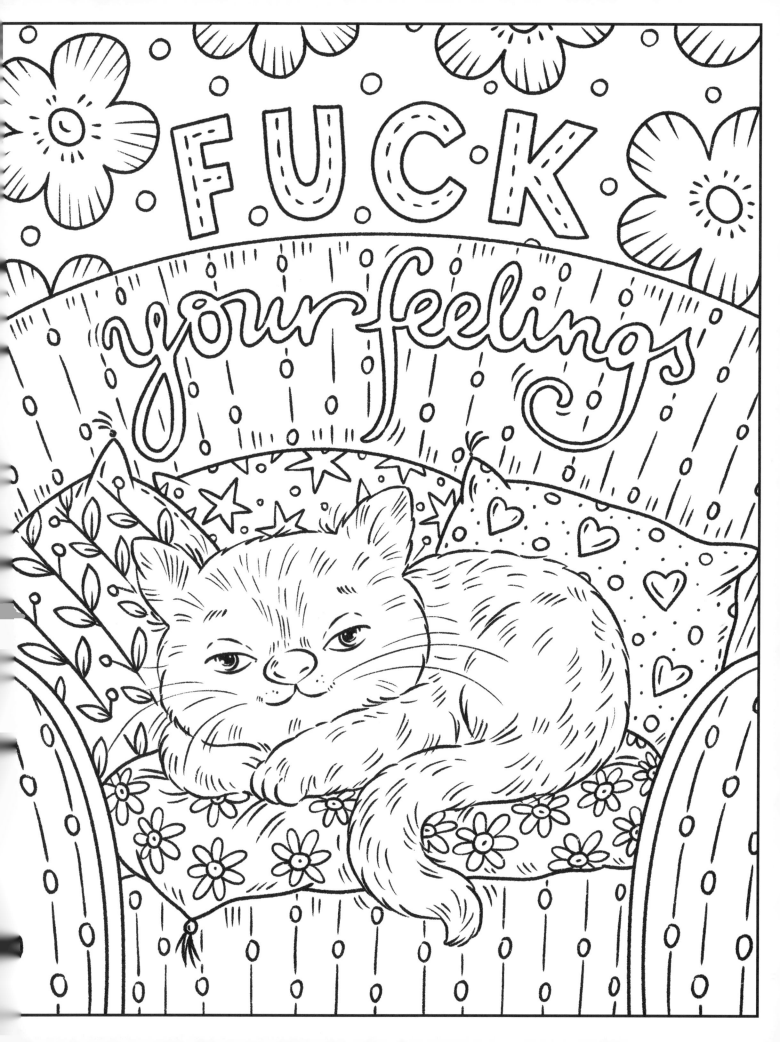

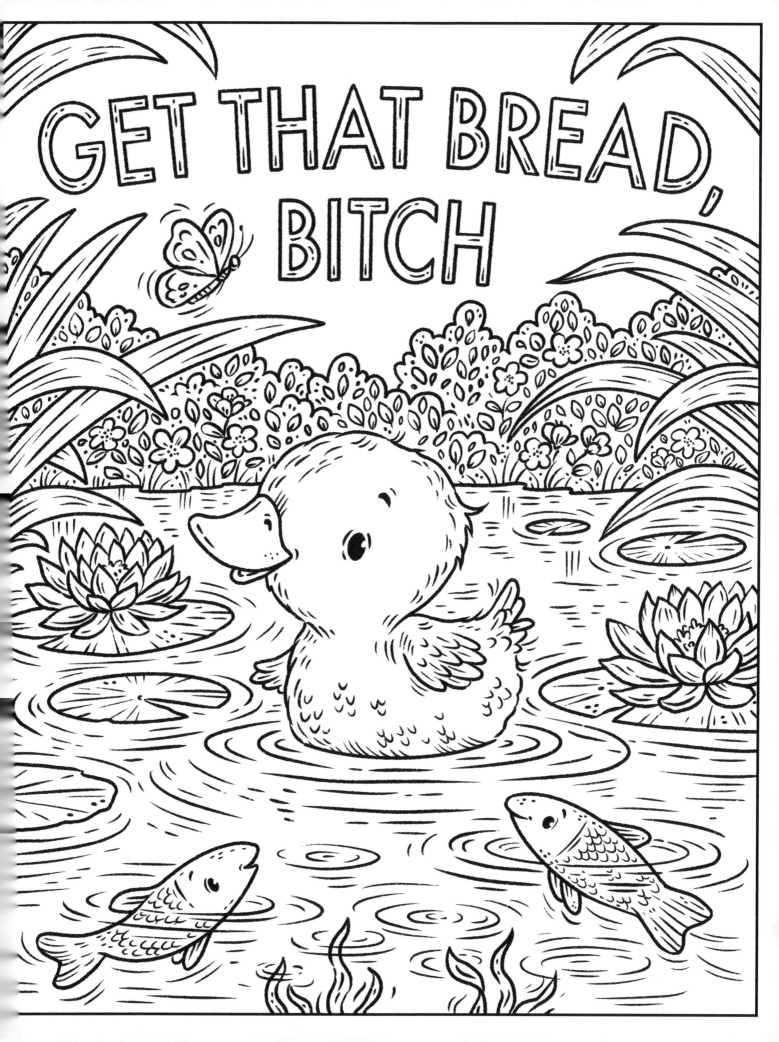

LIVING YOUR BEST LIFE

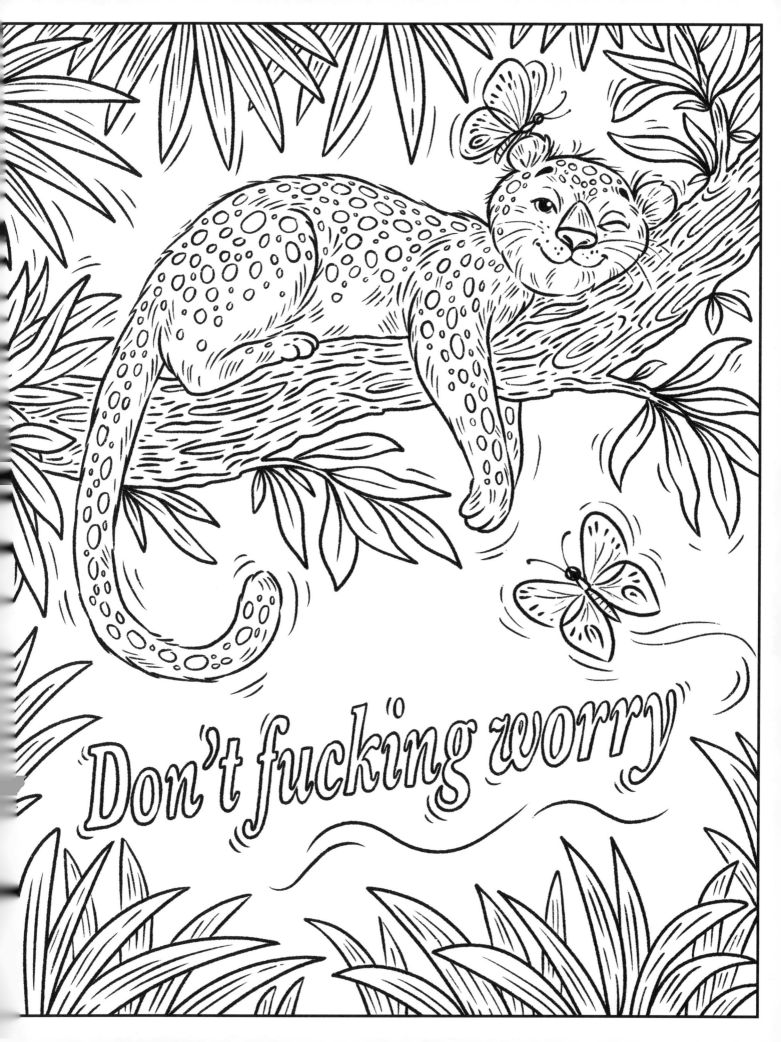

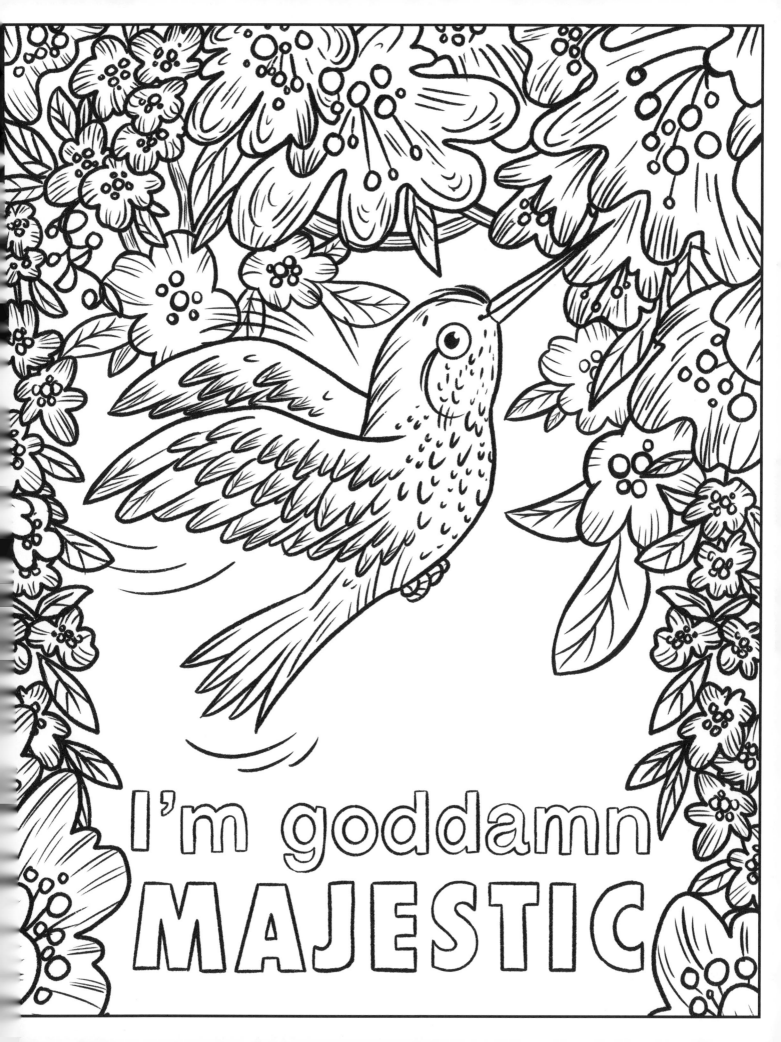

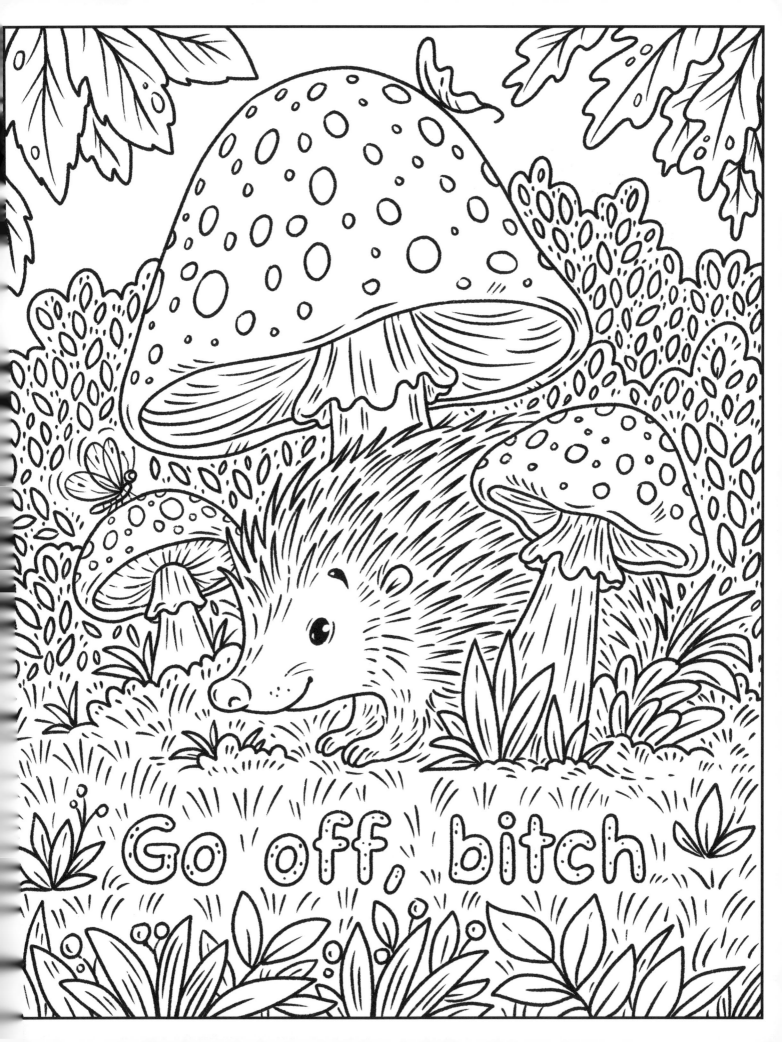

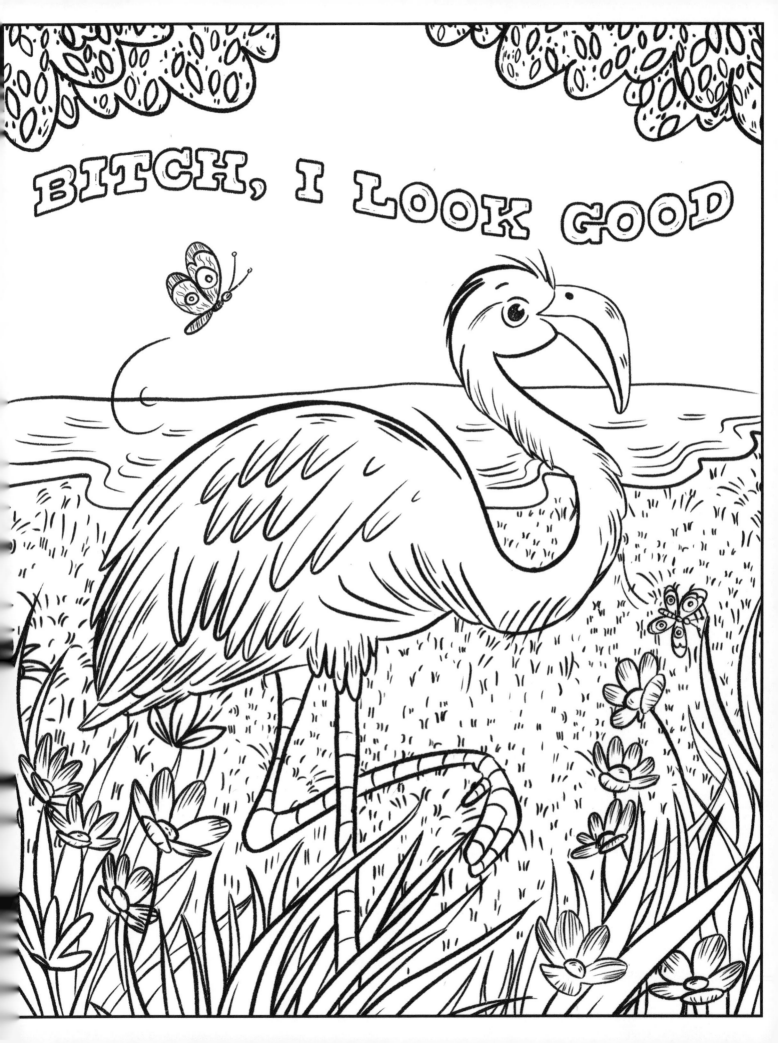

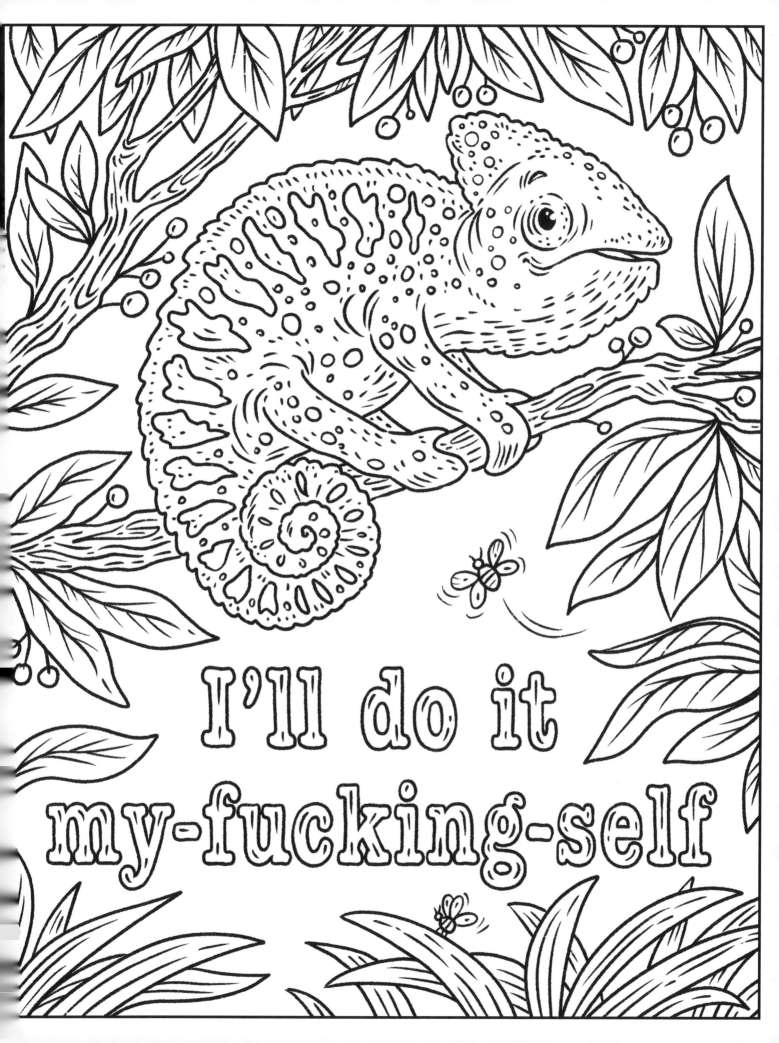

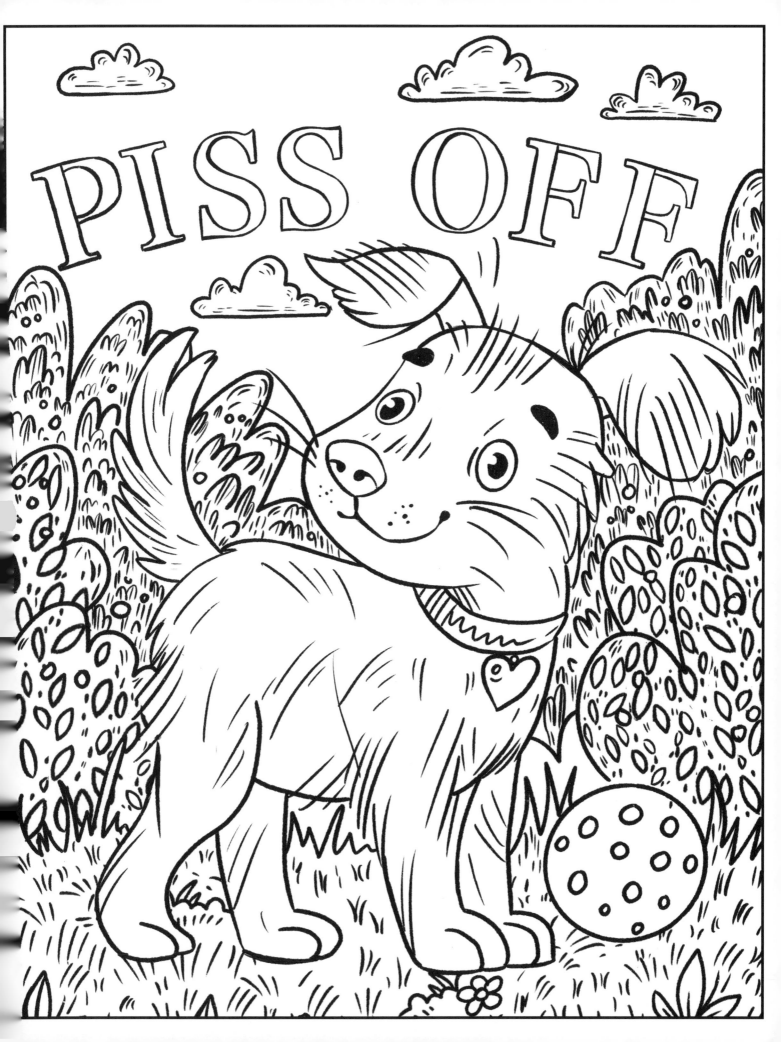

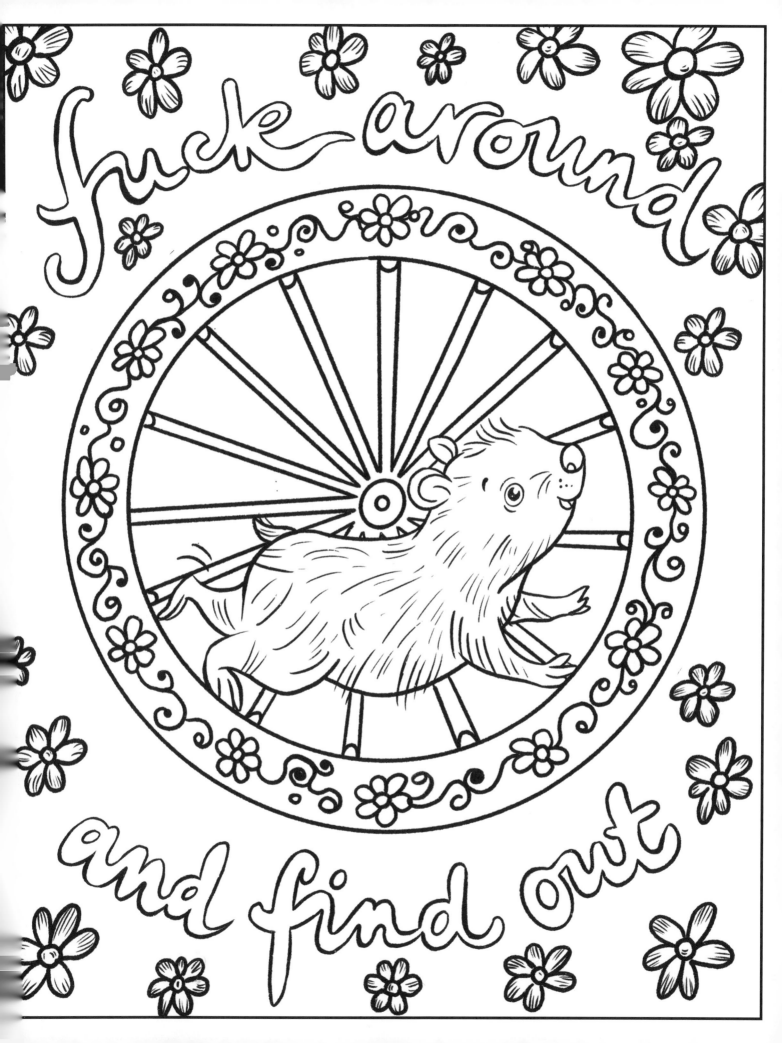

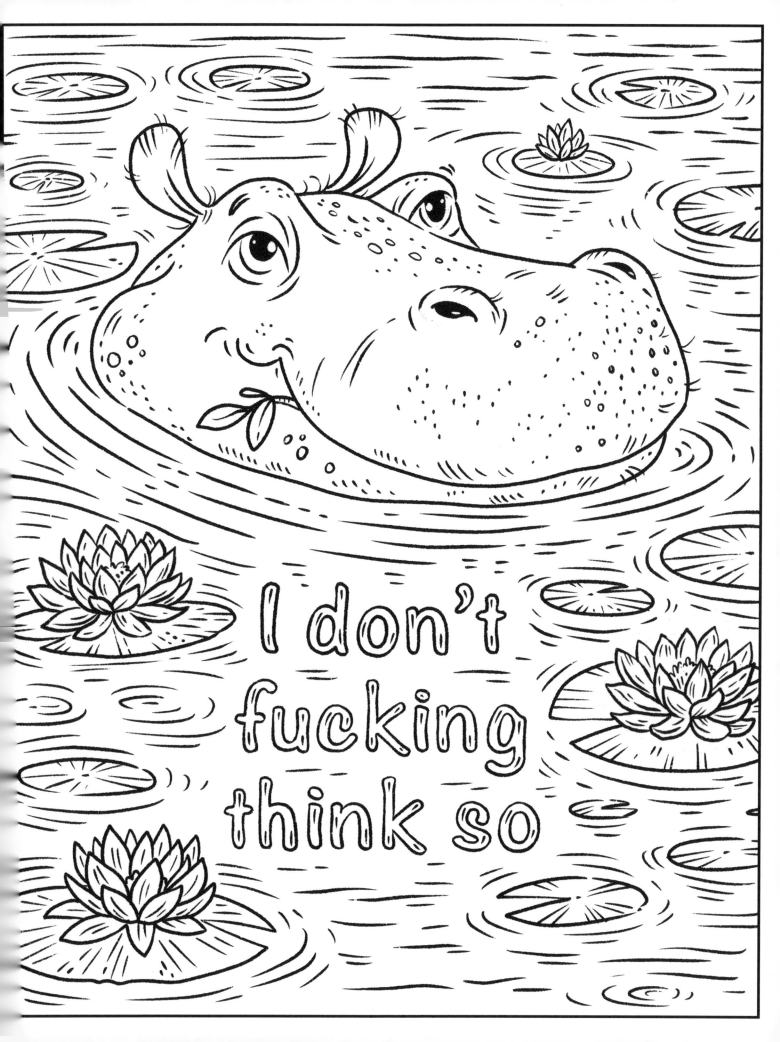

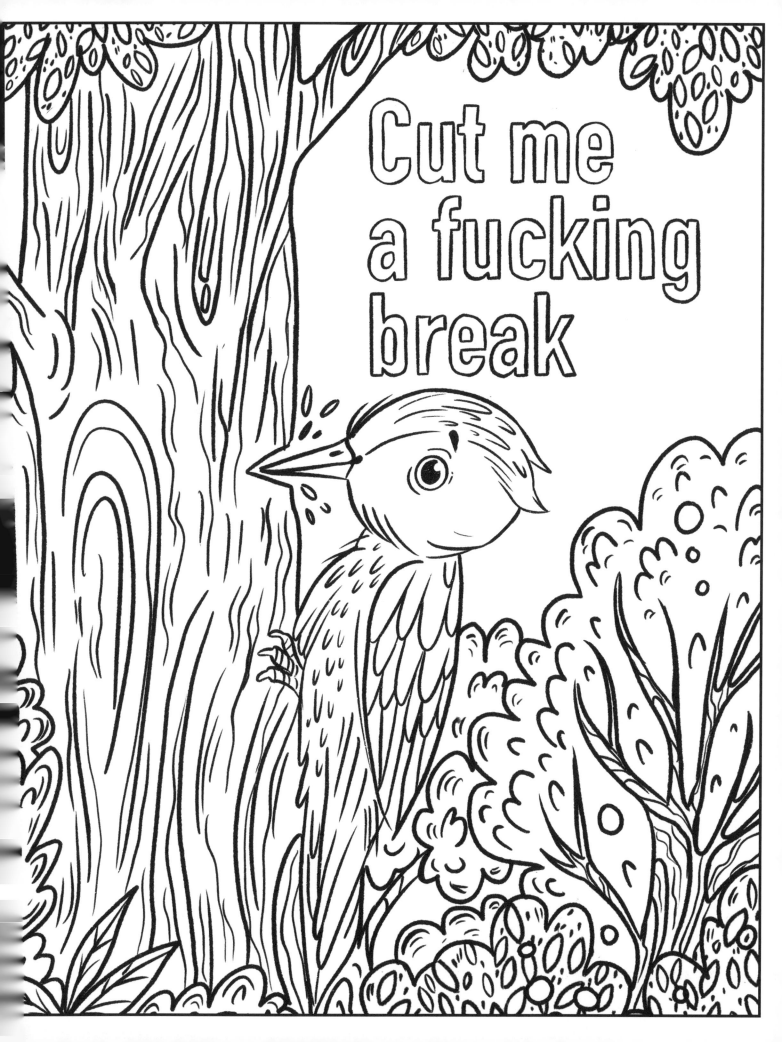

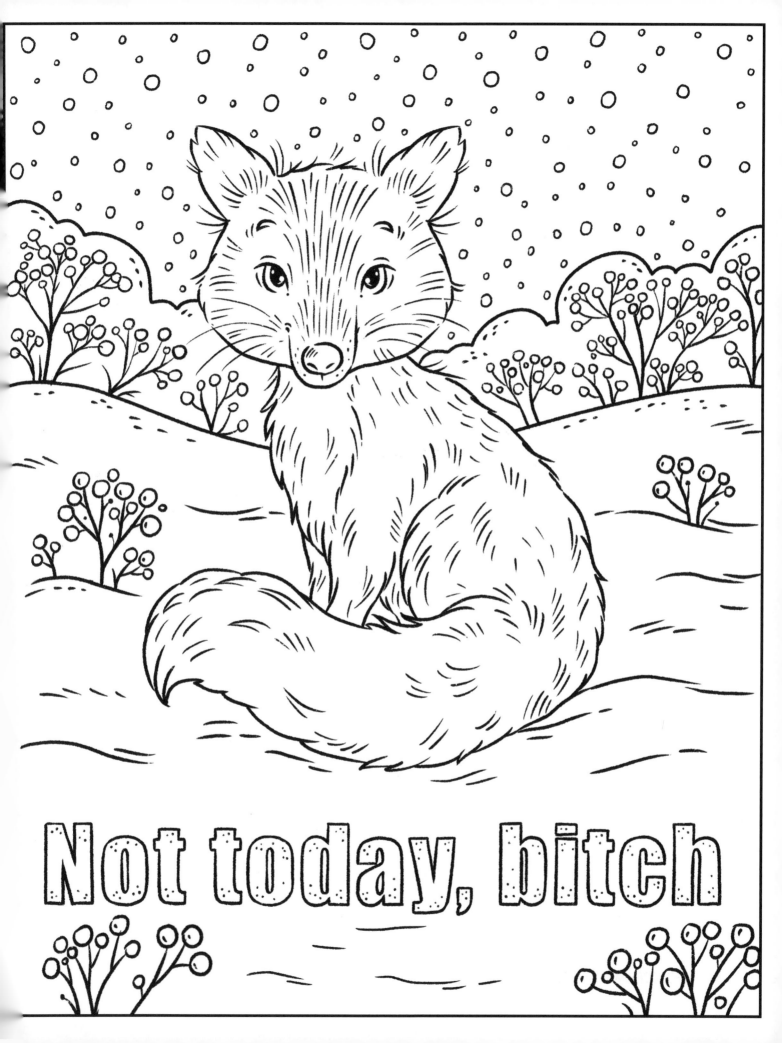

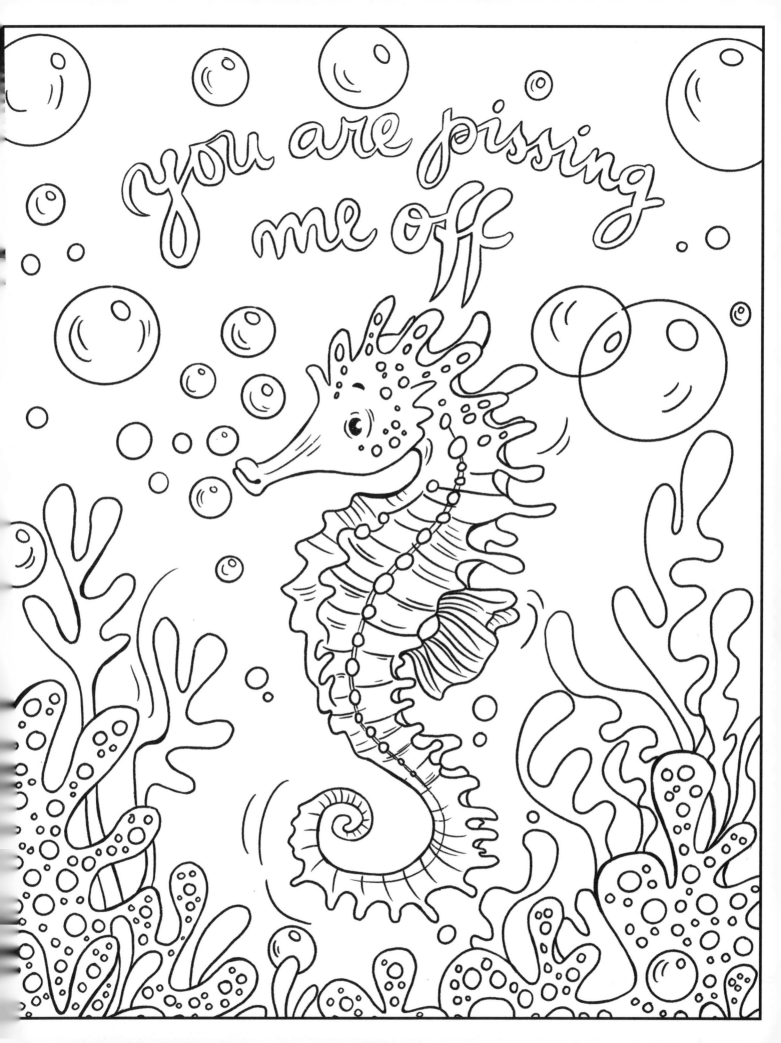

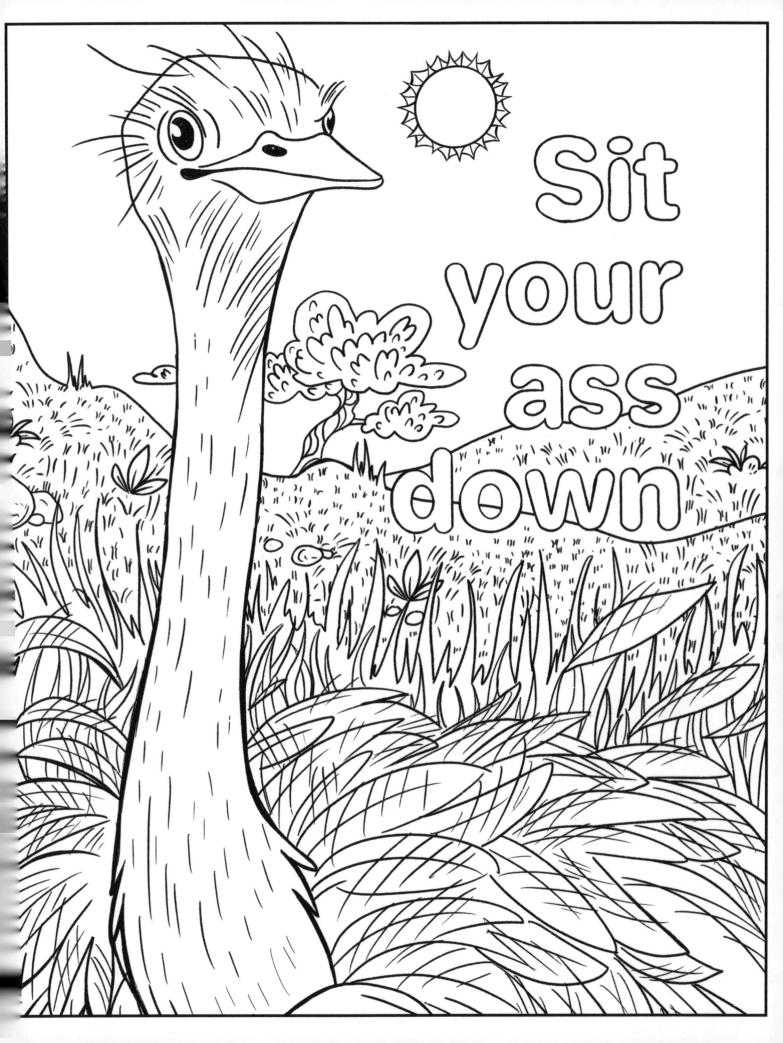

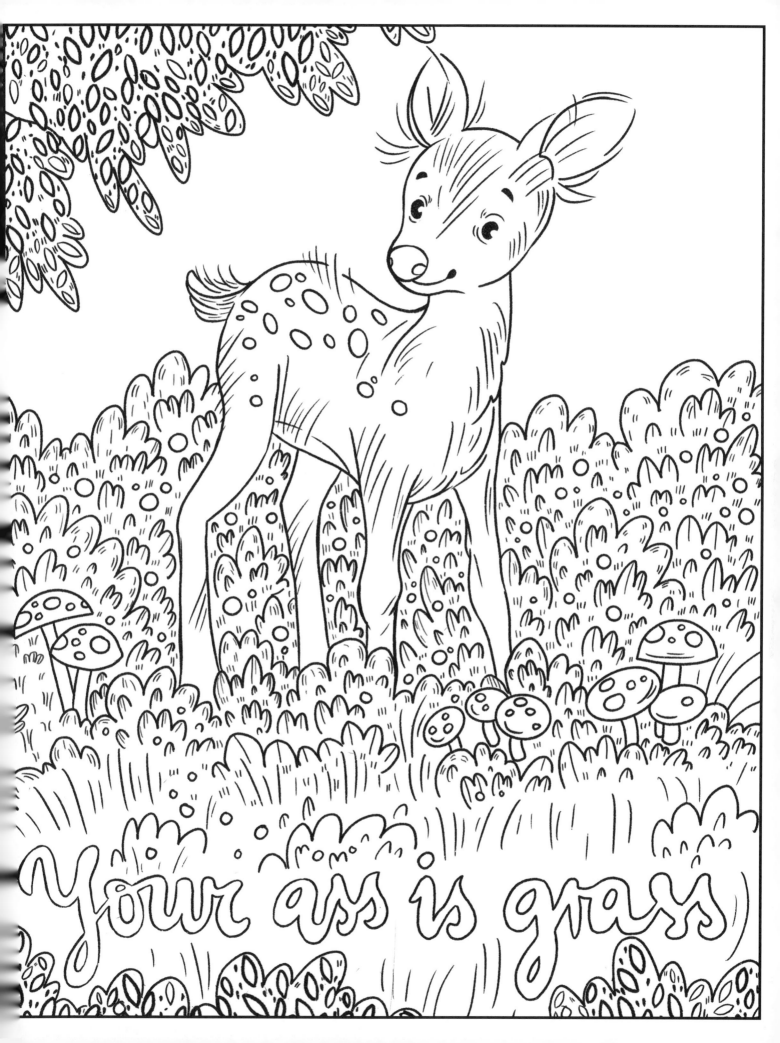

Your ass is grass

YOU'RE #1

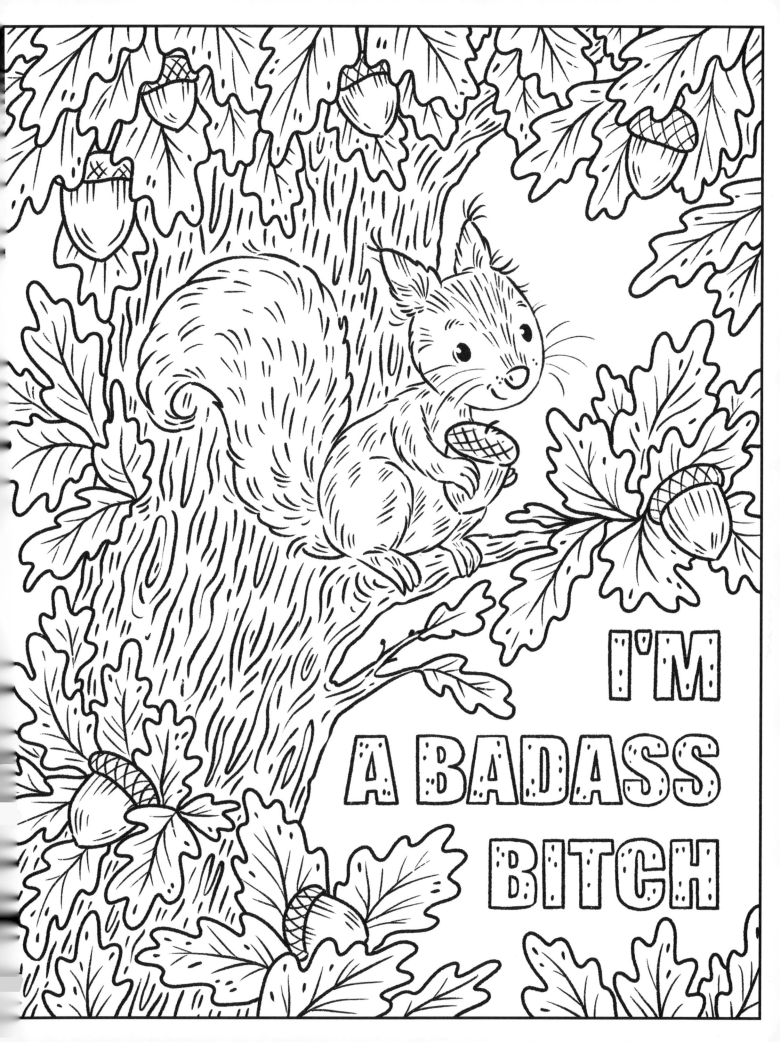

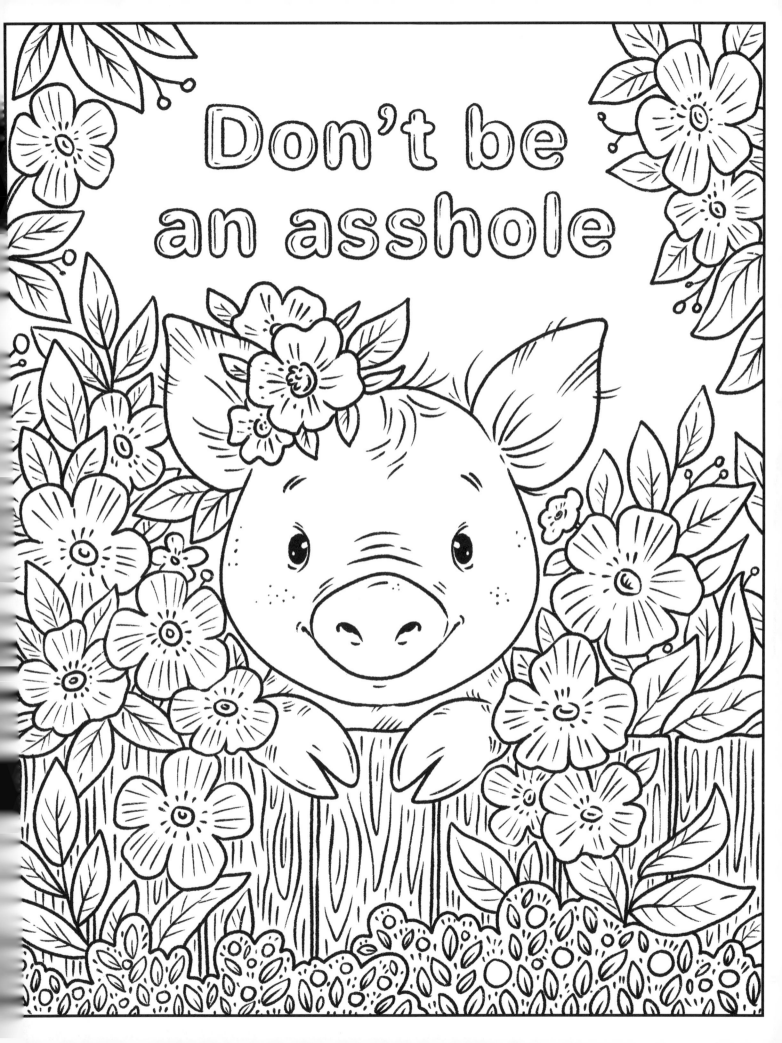

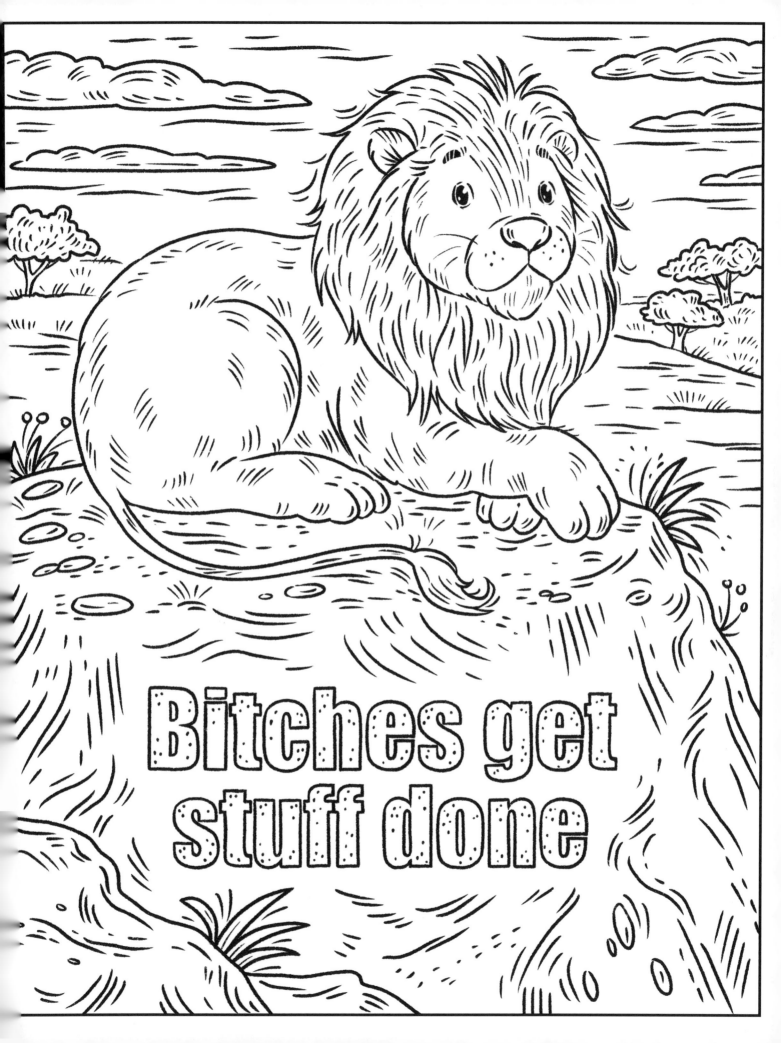

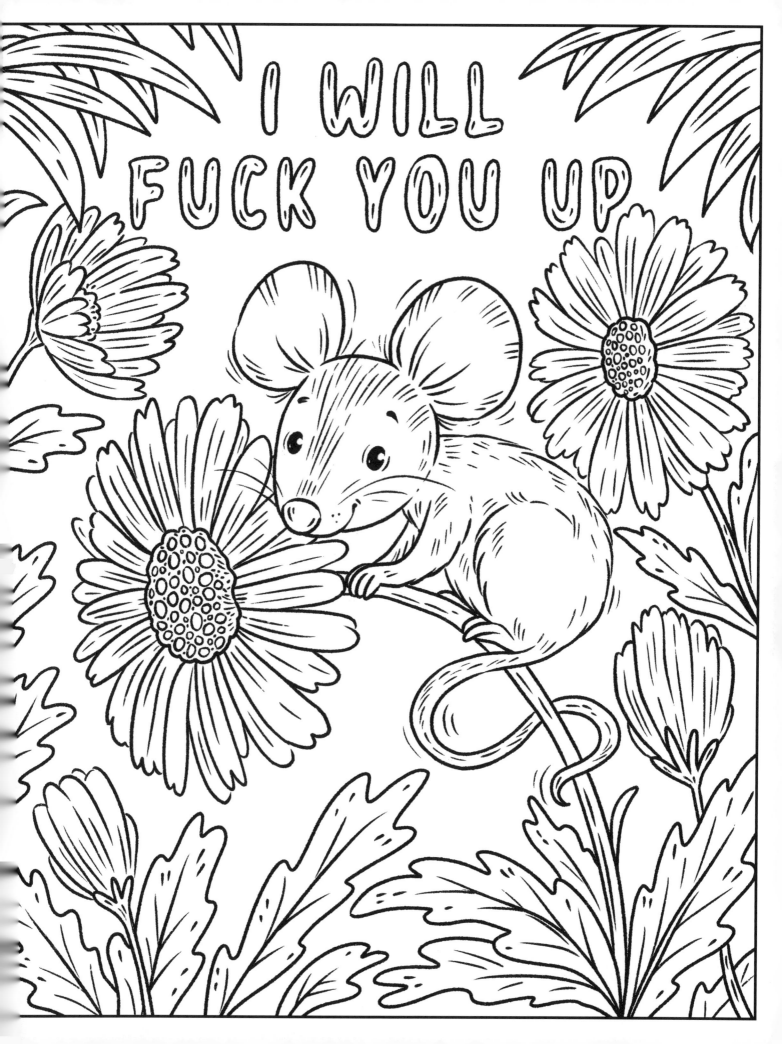

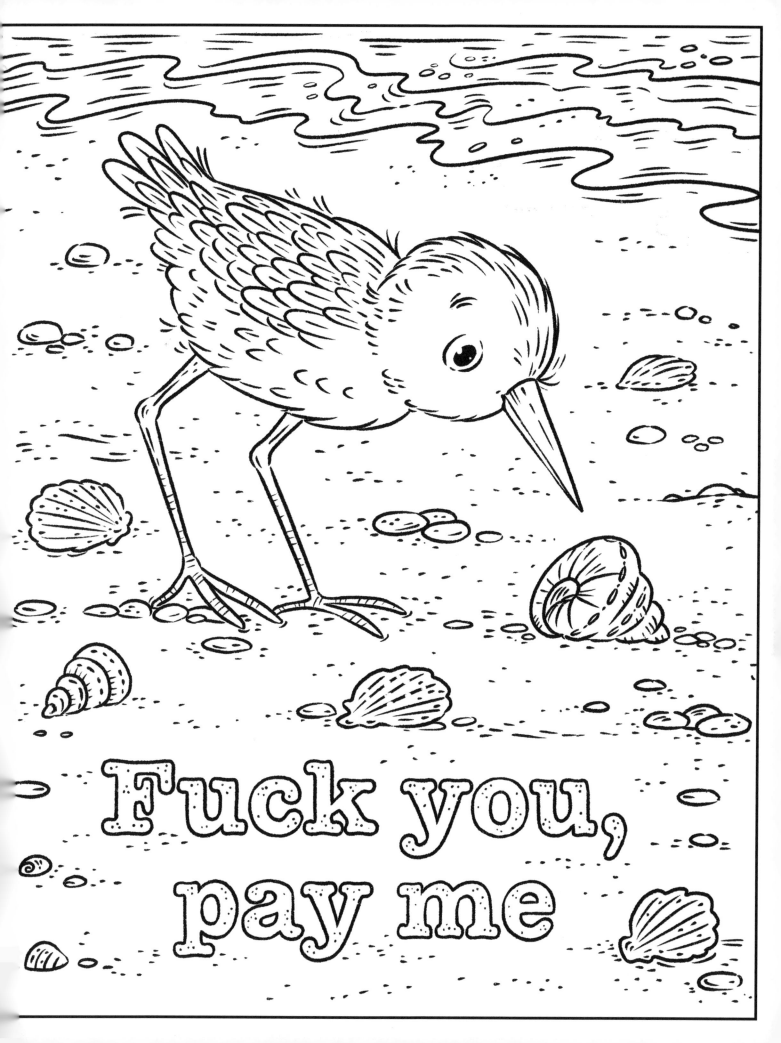

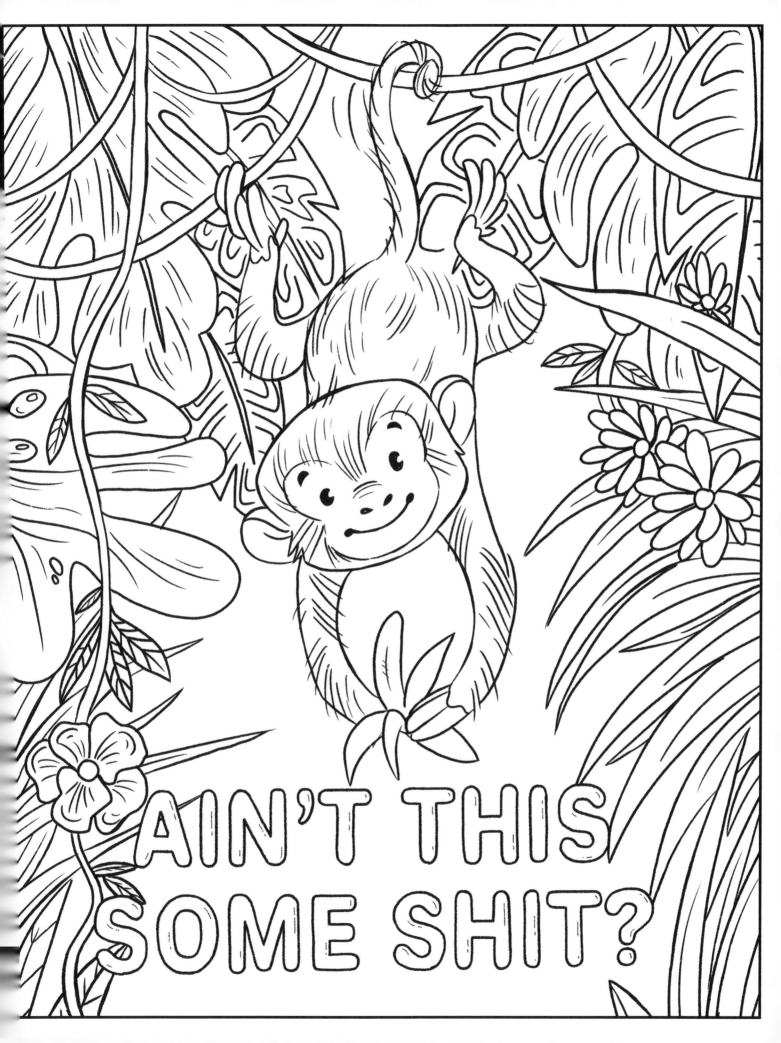

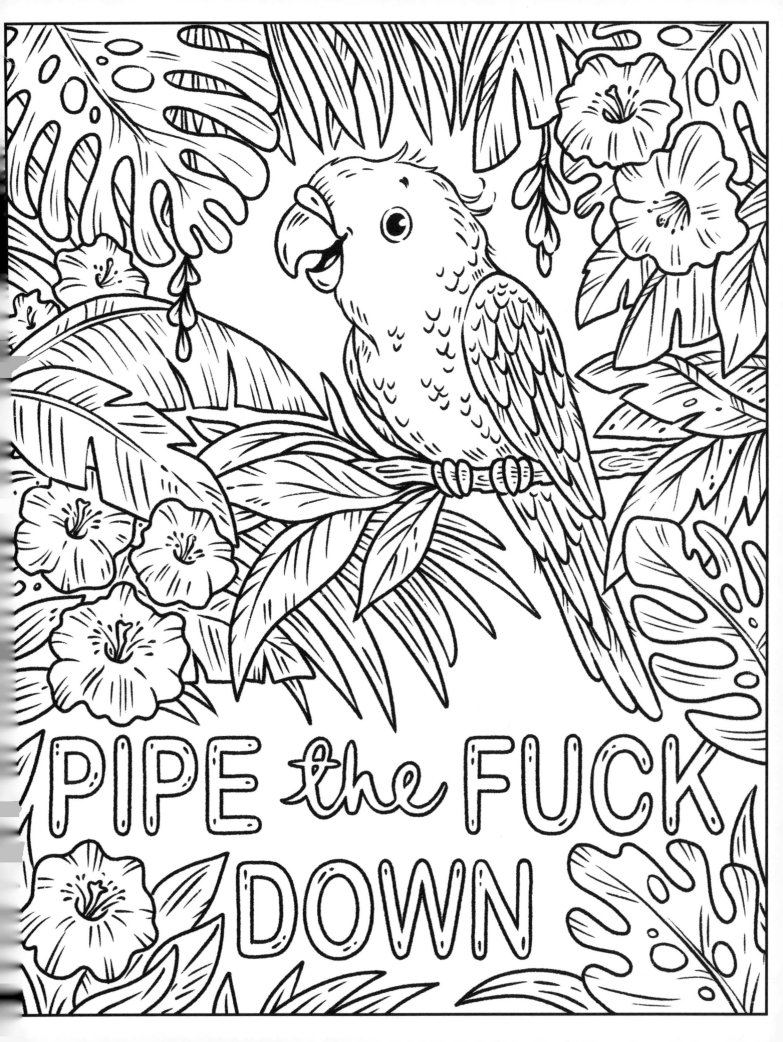

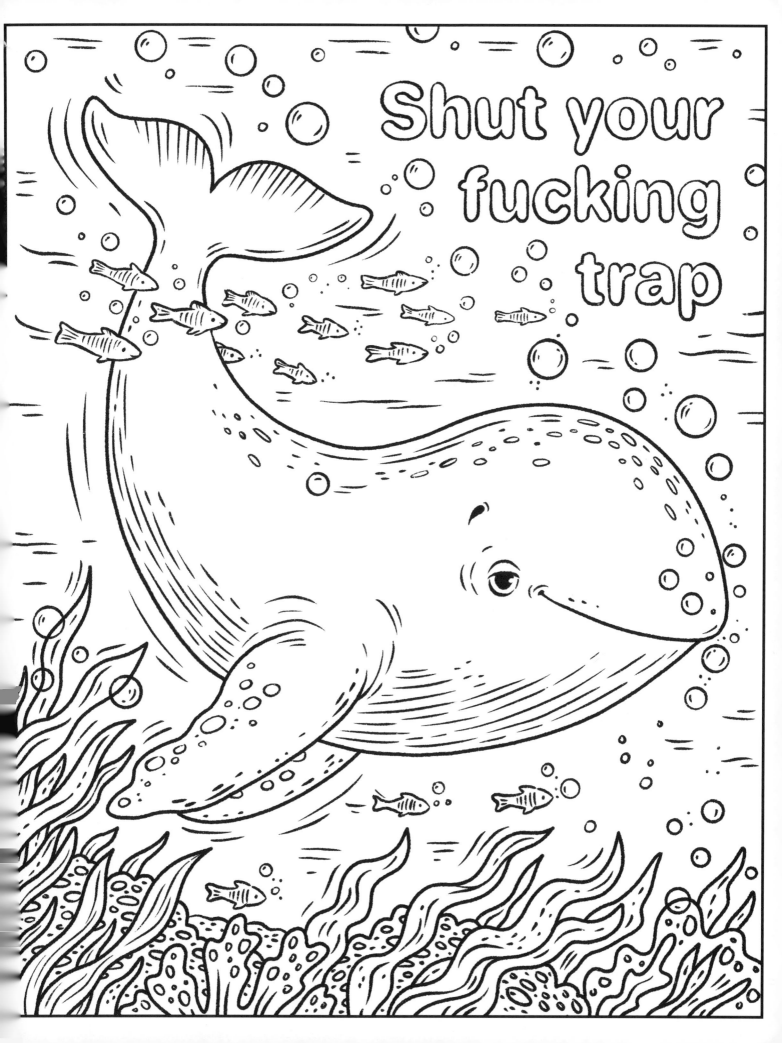

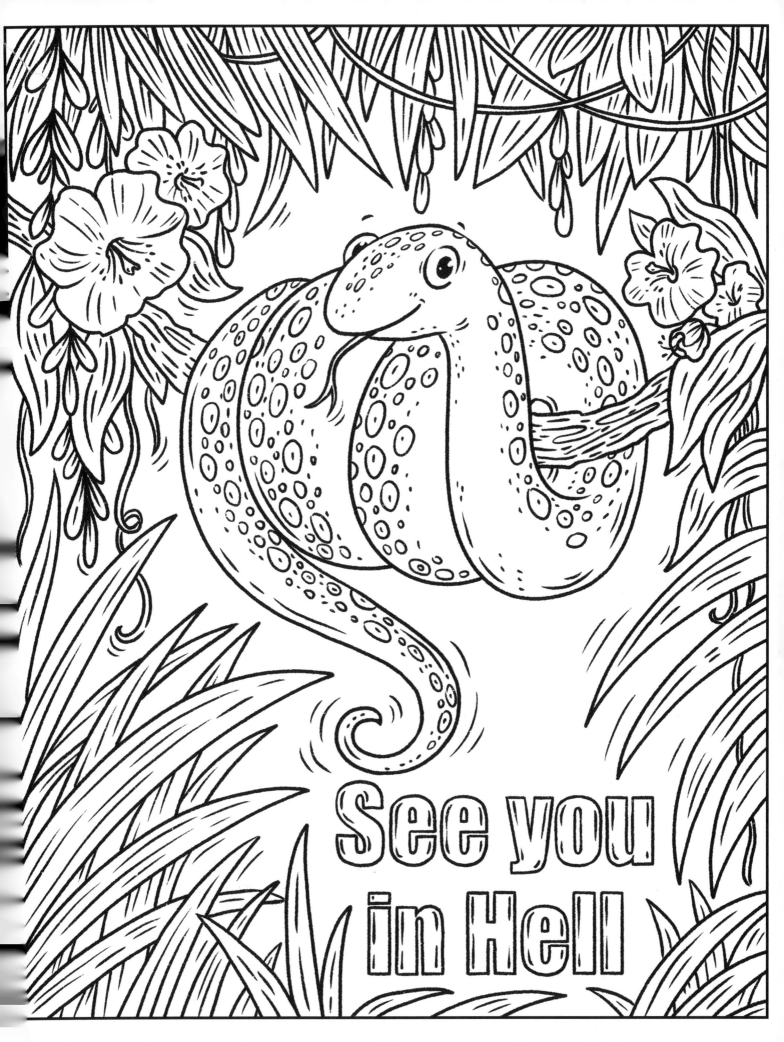

#FUCKOFFIMCOLORING #FUCKOFFIMCOLORING
#FUCKOFFIMCOLORING #FUCKOFFIMCOLORING
#FUCKOFFIMCOLORING #FUCKOFFIMCOLORING
#FUCKOFFIMCOLORING #FUCKOFFIMCOLORING
#FUCKOFFIMCOLORING #FUCKOFFIMCOLORING
#FUCKOFFIMCOLORING #FUCKOFFIMCOLORING
#FUCKOFFIMCOLORING #FUCKOFFIMCOLORING
#FUCKOFFIMCOLORING #FUCKOFFIMCOLORING
#FUCKOFFIMCOLORING #FUCKOFFIMCOLORING
#FUCKOFFIMCOLORING #FUCKOFFIMCOLORING
#FUCKOFFIMCOLORING #FUCKOFFIMCOLORING
#FUCKOFFIMCOLORING #FUCKOFFIMCOLORING
#FUCKOFFIMCOLORING #FUCKOFFIMCOLORING
#FUCKOFFIMCOLORING #FUCKOFFIMCOLORING
#FUCKOFFIMCOLORING #FUCKOFFIMCOLORING
#FUCKOFFIMCOLORING #FUCKOFFIMCOLORING
#FUCKOFFIMCOLORING #FUCKOFFIMCOLORING
#FUCKOFFIMCOLORING #FUCKOFFIMCOLORING
#FUCKOFFIMCOLORING #FUCKOFFIMCOLORING

SHARE YOUR BITCHIN' MASTERPIECES

Don't keep your colorful creations
to yourself—take a pic and share it
on social media with the hashtag
#fuckoffimcoloring and tag us
@cidermillpress!

For more stress-relieving coloring, check out:
Fuck Off, I'm Coloring
Fuck Off, I'm Still Coloring
Fuck Off, Coronavirus, I'm Coloring
Fuck Off, I'm Doing Dot-to-Dot
Bite Me, I'm Coloring
Available now!

INDEX

ABOUT
CIDER MILL PRESS
BOOK PUBLISHERS

Good ideas ripen with time. From seed to harvest,
Cider Mill Press brings fine reading, information, and
entertainment together between the covers of its creatively
crafted books. Our Cider Mill bears fruit twice a year,
publishing a new crop of titles each spring and fall.

DEYST.

"Where Good Books Are Ready for Press"

Visit us online at
cidermillpress.com
or write to us at
501 Nelson Place
Nashville, Tennessee 37214